# How To Draw
## GRAPHIC NOVEL -STYLE

# How To Draw
## GRAPHIC NOVEL-STYLE

### ANDY FISH

CHARTWELL
BOOKS, INC.

This edition published in 2010 by
Chartwell Books, Inc.
A division of Book Sales, Inc.
276 Fifth Avenue Suite 206
New York, New York 10001
USA

ISBN-10: 0-7858-2670-X
ISBN-13: 978-0-7858-2670-5
QTT.DCAS

A Quintet book
Copyright © Quintet Publishing Limited
All rights reserved.

This book was conceived, designed, and produced by
Quintet Publishing Limited
The Old Brewery
6 Blundell Street
London N7 9BH
United Kingdom

Project Editor: *Asha Savjani*
Designer: *Rehabdesign*
Art Editor: *Zoë White*
Art Director: *Michael Charles*
Managing Editor: *Donna Gregory*
Publisher: *James Tavendale*

Printed in China by Midas Printing International Ltd.

# Contents

# Chapter 1

# What is drawing graphic novel-style?

**LEARNING HOW TO DRAW GRAPHIC NOVEL-STYLE MEANS LEARNING TO CONVEY A STORY AND A CHARACTER'S EMOTION THROUGH IMAGES**

# WHAT IS DRAWING GRAPHIC NOVEL-STYLE?

**G**raphic novels are comic books grown up—well sort of. Much like regular literature, it's hard to just group an entire method of storytelling into one single description.

Graphic novels can be about a wide variety of subjects and genres, but mostly the art is somewhat more advanced than a regular comic book.

Where your typical comic book might show a bank robber like this, a graphic novel uses a more sophisticated method of combining words and pictures to convey its messages.

This more sophisticated method of storytelling allows graphic novels to tell stories in limitless genres: crime, biography, slice of life, drama, fiction, sci-fi, horror, and yes, sometimes even superheroes—as in the case of Alan Moore's *Watchmen* or Frank Miller's *The Dark Knight Returns*.

In the case of these two graphic novels, the authors approached a subject normally reserved for more juvenile works (superheroes) and told very complex stories with adult themes.

Graphic novels are typically longer narratives in book form, sold in bookstores and comic book stores. Many libraries are now expanding their graphic-novel sections to include the multitude of new titles being released every month. Many have received critical acclaim—*Maus* by Art Spiegelman won a Pulitzer Prize for Non-Fiction and *Persepolis* by Marianne Satrapi won the Angoulême International Comics Festival Prize for Scenario in Angoulême, France, for its script and in Vitoria, Spain, for its commitment against totalitarianism.

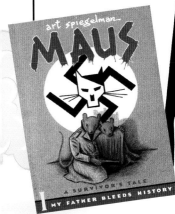

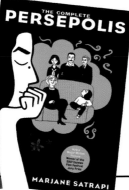

**left:** Prize-winning graphic novels have received critical acclaim worldwide.
**above:** Graphic novels tell stories in limitless genres.

## What is your studio set-up?

If you're just starting out, a regular table and chair with some good lighting can be enough, but most serious graphic novelists have a designated studio area (inside or outside their homes) where they can work. No matter your circumstances, you should always buy the best equipment you can afford.

### You will need

**1.** A comfortable chair—because you'll be spending a lot of time on it working.

**2.** Excellent lighting—an adjustable lamp is best. You'll need good lighting to see what you're doing.

**3.** A drawing table—many artists, myself included, like a table set with an extreme angle—otherwise stuff piles up on the work area.

**4.** A cup or other such holder for pens and pencils.

**5.** An area to hold your ink bottle and brushes.

**6.** A clean area to put your coffee or tea (indispensable to most artists).

## Tools of the trade

When you break it down to the bare minimum, you need pencils, pens, and paper—it depends mostly on what you are comfortable working with, but if you want to get "real" you can't work without the following.

### Pencil leads

These come in a variety of types—all based on how hard or soft the lead is. A softer lead will put down a darker line, which can also be messy, while a harder lead will give you a lighter line but can be hard to see.

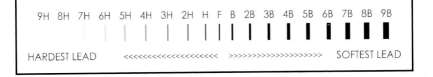

```
9H  8H  7H  6H  5H  4H  3H  2H  H  F  B  2B  3B  4B  5B  6B  7B  8B  9B

HARDEST LEAD    <<<<<<<<<<<<<<<<<<<<    >>>>>>>>>>>>>>>>>>>>    SOFTEST LEAD
```

As you can see, H, HB, F, and B are the middle of the spectrum of lead line weights, and as you move up or down the chart you get a harder or softer lead. 9H is almost like drawing with a pin while 9B is comparable to drawing with pastel crayons. I work with 2B lead in a 0.5mm mechanical pencil, but I also keep handy some regular pencils as well as a few colored pencils for page layouts. Really it's personal preference and you should try a variety of pencils until you find the ones you prefer.

Non-photo repro blue pencils are popular with a lot of artists for layouts. The blue pencil lines don't reproduce when printed and you can tighten them up with a "regular" pencil.

### Rulers, T-squares, and triangles

Metal ones are best because wood can warp and chip, which will give you uneven lines—and what's the purpose of a ruler with crooked lines?

### Pencil sharpeners

Keep that pencil sharp. You'll get better, cleaner work if you draw with a sharp tip.

## Erasers

White polymer erasers are fantastic—they are clean, work great, and leave no residue. Gum erasers are good but they get hard and dirty over time. The pink erasers are for grade school kids and can actually damage your paper when you use them.

## Pens and inks

Disposable pens are okay, but they don't give you a great line. Microns and Sharpies might be easy to use (see page 209 for a list of suppliers), but if you choose a nice titanium quill and some high-quality ink you'll be amazed at the difference in your work.

For ink, I stick to Deleter brand, which is a smooth, black, water-soluble ink and gives the look of a high-grade India ink without the hassle of trying to clean it (India ink tends not to wash off tools, clothes, or hands).

A: COMIC ART BOARDS
B: BRUSHES
C: TECHNICAL PENS
D: MARKER
E: DIPS (QUILL PENS)
F: PENCILS
G: INK
H: ERASERS

## Paper

11 x 17in (28 x 44cm) bristol board ruled to 10 x 15in (25 x 38cm) is standard size for comic books. But for graphic novels the sky is the limit. Some artists like to work landscape style, others are more traditional, while still others choose square sizings—it's really up to you.

Bristol is an excellent choice though, and you can have it cut into any size you want. It comes in one-, two-, or three-ply with the higher number more like a board than a piece of paper. Bristol is available either as a smooth surface or a rough surface (vellum). The higher number is best if you are someone that wants to try some extreme effects like taking a razor and scraping it in your inks (see page 90). Personally I use a three-ply bristol with a vellum surface, very similar to the paper Marvel Comics uses for its artists.

## Computer and scanner

Years ago Macs were the only way to go, but today PCs have come a long way toward catching up. I find I use my Mac and my PC about the same.

Ideally you'll want a scanner that can handle paper up to 11 x 17in (28 x 44cm) so you aren't forced to scan in pieces, but these can be a bit pricey— shop around because prices are dropping. A scanner is important because you'll want to be able to make corrections, as well as coloring and lettering on the computer. Most publishers and printing companies want the files delivered digitally as well so you'll already have that covered if you work this way.

## Graphic novel-styles

**LIMITED LINE**
Alex Toth, David Mazzuchelli, The Hernandez Bros.

**CARTOONY**
Richard Sala, Craig Thompson, Art Speigleman

**ABSTRACT**
Frank Miller, Jack Kirby, Guy Davis

**REALISM**
Neal Adams, Mark Schultz, Paul Ryan

**GRAPHIC**
Charles Burns, Chris Ware, Dan Clowes

**HEAVY LINE**
Jim Lee, Will Eisner, Todd McFarland

Just as there are many different genres in the graphic-novel field, there are an equal number of artistic styles—from cartoony to photo realistic. Books like *Superspy* by Matt Kindle or *Goodbye Chunky Rice* by Craig Thompson are drawn in a style you'd more likely associate with humor, which has the effect of making the real-life violence featured in them all the more shocking.

Some artists, like Craig Thompson, can work in a variety of styles. His book *Blankets* is done in a more realistic sketchbook style than *Chunky Rice*. The style you choose to work in should both reflect your natural style and complement the story you are trying to tell.

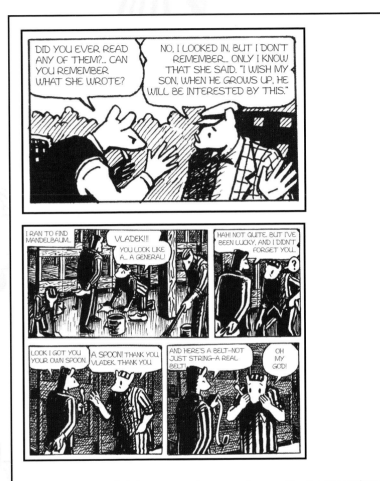

Mixing genres and styles can produce amazing results. Art Spiegelman decided to recreate the horrors of the Holocaust in a humorous animal style when he told about his father's first-hand experience of it in the award-winning *Maus*. The idea that Jews are depicted as mice while Nazis are cats creates both a visually stunning metaphor and emphasizes the nightmarish existence he endured.

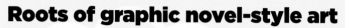
# Roots of graphic novel-style art

Mankind has been telling stories sequentially since the dawn of time, starting with the medium of cave walls. The Egyptians and the Mayans often carved stories written in pictures, long before any form of language was adopted.

Comic books were born from comic strips in the early 1930s, when publishers started reprinting comic strips in magazine-style form and sold them on newsstands. They soon realized that if they opted to produce new material for these comic books with artists who were looking for work, they could make a bigger profit and soon titles like *Detective Comics, More Fun Comics*, and *Action Comics* were on newsstands offering all new material.

It was *Action Comics #1* (1938), however, that changed everything.

*Superman* appeared in this landmark book—the first costumed superpowered being—and he was a smash hit. Soon the market was flooded with copies of *Action Comics*, followed by his own title, *Superman*. DC Comics (then known as National Comics) rode the wave of super success and, a year later, offered a character who would eventually rival their flagship's success—Bob Kane's mysterious pulp-inspired hero, the Bat-Man, appeared in *Detective Comics #27* in May 1939.

With World War II, the popularity of comics boomed as soldiers took to reading them during their downtime, causing the art form to rise in popularity—rivalling and eventually surpassing the success of pulp magazines such as *The Shadow* and *Doc Savage*—ironically the characters who were the inspiration for Bat-Man and Superman.

It was Europe and Japan, however, that began offering more deluxe versions of comic books, often in hardcover formats.

It is extremely difficult to pin down the first "graphic novel." Taking out reprints and focusing on all new material, American artist Gil Kane and writer Archie Goodwin's *Blackmark* was first published as a "comic paperback novel" in 1971, featuring 119 pages of all new material with a character specifically created for this art style.

## What is a graphic novel and how is it different from a comic book?

David Kunzle, author of *The History of the Comic Book*, gives this definition of a comic book:

**1.** Sequence of separate images

**2.** Preponderance of images over text

**3.** Story must be reproduced and mass produced or distributed

**4.** Sequence must tell a story

**5.** Multiple images must be read in a certain order to follow the narrative

I'd go a bit further to differentiate graphic novels from comic books:

**1.** Narrative must tell a complete story. In other words, a book reprinting *Spider Man* comics #13–25 is a collection of a continuing story and would, therefore, be considered a trade paperback collection and not necessarily a graphic novel. *The Dark Knight Returns* tells the complete story of Batman's retirement and return to crime fighting, qualifying it as a graphic novel.

**2.** Work must be by a single creator or creative team. Again, collected editions of ongoing serials don't fit this description.

**3.** Story must have elements elevating it above regular "comic book" fare. Characters should be well defined, situations sincere, and development should occur during the length of the story.

**4.** Manner in which the story is told should strive for advanced techniques (see page 8) rather than straightforward sequentials, or the narrative itself should address subjects considered mature.

**5.** Graphic novels are generally 48 pages or more, to allow square bond and therefore "book" binding.

## History of the graphic novel

The term "graphic novel" was first used in 1976 with three separate works: *Bloodstar* by Richard Corben, adapting a story by Robert E. Howard, used the term on its dust jacket and in the introduction. George Metzger's *Beyond Time and Again* was subtitled *A Graphic Novel*, and Jim Steranko's *Chandler; Red Tide* was printed digest-size and designed to be sold on newsstands, although many argue that it was more an illustrated novel than a work of comics.

*Sabre: Slow Fade of an Endangered Species* by Don McGregor and Paul Gulacy was published in 1978 and was the first graphic novel intended for the newly created "direct market" of United States comic bookstores, but most "experts" will tell you that the first graphic novel was Will Eisner's *A Contract with God*.

Eisner was one of the first creators to have the vision that comics and books could entertain subjects outside of costumed superheroes and *A Contract with God* proved that. Many consider Eisner the father of the modern graphic novel, an innovative creator who cut his teeth on the classic post World War II strip *The Spirit*. His graphic novels include: *A Contract with God* (1975), *Life on Another Planet* (1983), *New York: The Big City* (1986), *The Dreamer* (1986), *The Building* (1987), *A Life Force* (1988), *To the Heart of the Storm* (1991), *Invisible People* (1993), *Dropsie Avenue* (1995), *The Princess and the Frog* (1996), *A Family Matter* (1998), *Last Day in Vietnam* (2000), *The Last Night* (2000), *Minor Miracles* (2000), and *The Plot* (2005).

## The language of the graphic novel's author

You can't read a regular book without punctuation, can you? Of course not. Well, the same goes for graphic novels—there are elements in the design and layout of just about every graphic novel that need to be followed and understood by both creator and reader so that the story can be clearly told.

# Terminology

**bleed** The term used when an artist draws the action off the page.

**box** Can be first-person narrative or an omnipotent narrator.

**emanata** Symbols used to represent words or sounds. Showing a light bulb over someone's head, or a horn in a word balloon to represent the honking sound, etc.

**gutter** The space between your panels. Variable based on the artist's choice, but $1/4$ in (0.6cm) is the norm and offers the best readability.

**lettering** The written words which tell your story. Some graphic-novel authors do the lettering by hand, some use computers.

**motion lines** Lines drawn to show speed or movement.

**narrative** A squared-off box, normally rectangular, in which the narrator speaks.

**page** As simple as it sounds, this is the page on which all your action takes place. It takes a lot of pages to make a complete graphic novel.

**Splash page:** A full page of art without any panels. Used for dramatic effect.

**Double page spread:** Two pages in which the image crosses the binding to create one large image.

**panel** The boxes on your page which hold your images.

**sound fx** Done with lettering—it needs to be differentiated from the "regular" speaking lettering, usually with a thicker, more "designed" style of font choice.

**word balloons** Usually done with a pointer to indicate who is talking.

**thought balloons** Today these bouncy, cloud-like balloons are mostly used with comic strips, as balloons. Comic book publishers have opted to hold a character's thoughts in a narrative box instead. Thought balloons are often thought to be too "cartoony."

**word** Sometimes called "word bubbles," these are the text holders on your page.

# Chapter 2

# Characters

REALISTIC CHARACTERS ARE
CRUCIAL. YOU HAVE TO GET
INSIDE THEIR HEADS AND
REALLY GET TO KNOW THEM
IF YOU WANT TO BE AN
EFFECTIVE GRAPHIC NOVELIST

# GRAPHIC-NOVEL CHARACTERS

**W**ell-defined characters practically write themselves. When designing your characters you should try to make them look like they have lived, not like they were just opened fresh from a box. Remember: your characters should have existed before your story takes place and a good design will reflect that.

Think about personality types when creating characters; essentially it's recognized that there are four types of personality traits (with variations and infinite combinations as well).

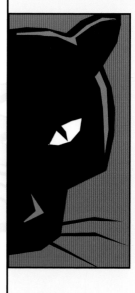

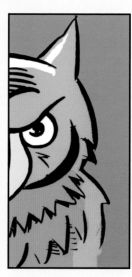

**1. A PANTHER**
Someone who can be intimidating. Results-oriented, they often take leadership positions. Can be impatient, very direct, and to-the-point.

**2. AN OWL**
One who likes a lot of information, is very detail-oriented, and prefers to work behind the scenes.

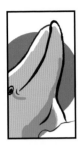

### 3. A DOLPHIN
Someone who likes helping others and is a team player.

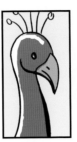

### 4. A PEACOCK
Someone who is a socialite and loves being the center of attention.

Consider the personality traits you are giving your characters. If someone is an owl type they probably won't be the leader of a team—since they will be too busy analyzing the facts to lead. Same goes for selecting a panther for your cheerleader character—they are probably going to be too direct and impatient to properly motivate others.

Some creators go so far as to give their characters a background (at least in their own mind—they don't share this with their readers):

**1.** Does the character have a lot of friends? Why or why not?

**2.** What was the character's experience like in High School? What social group (if any) did they belong to? Nerd? Jock? Brain?

**3.** What is the character's family life? Parents? Children? Siblings? Significant others?

**4.** Does the character have any pets? Did they? Are they a dog or a cat person?

**5.** What about specifics? Age? Political affiliation?

Some of these questions might seem ridiculous but the more you can get your own head around the attributes of a particular character's personality details, the easier they will be to write, and the more realistic they will seem to your readers.

# Drawing lesson

### The human—and not so human—head

With all of these art instructions, the rules are based on the style of art you've chosen to use.

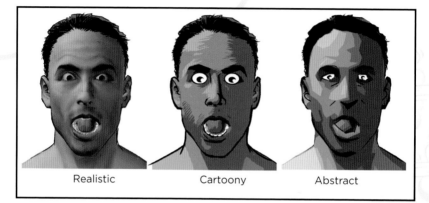

| Realistic | Cartoony | Abstract |

If you are drawing in a realistic style you'll need to follow the rules of proportions fairly closely. If you are working in an abstract or cartoony style then the rules go right out the window.

Head shapes are unique to each character and are one of the best ways to create different looks for your new beings (you should think of them as living creatures).

Start with a circle, keep it loose, add an extended line for the jawline; deciding something as simple as how long, straight, or wide this line is will give you a variety of head styles.

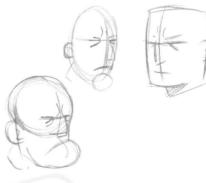

The human head is *amazingly* proportionate, so start with these proportion lines:

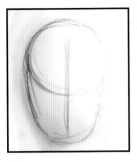 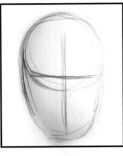 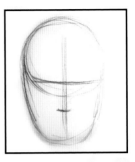

**Step 1:** Draw a vertical line down the center of the head. You want to make sure you keep the features balanced. This'll help you when you do a ³/₄ view as well (more later).

**Step 2:** Halfway down this line is the eye line, so draw a horizontal line straight across.

**Step 3:** Halfway from the eye line to the bottom of the chin is the nose line, so draw a shorter horizontal line here to mark where the nose is going.

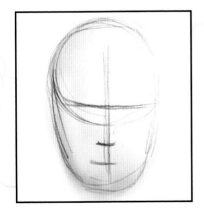

**Step 4:** Halfway from the nose line to the bottom of the chin is the mouth line—same thing here, draw a horizontal line here for the mouth.

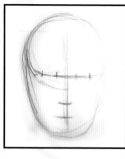

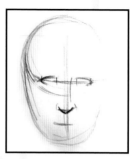

symmetrical, so draw these four lines to create space for the eyes.

**Step 6:** Start to put a bit more detail in the nose (see nose options, below) and begin work on the eyes, starting with the upper lid. This line should be a bit darker than the lower lid line.

**Step 5:** Now, going back to the eye line, mark off division lines for the eye sockets. The space between the eyes is the same size as the eyes themselves. The human face is very

## Nose options
There are several ways to draw a nose.

### Upside down 7
This is the one we start using when we first learn how to draw—and it's actually a pretty good start. Just add some details like a nostril and give the bridge a little bit of a bend and you've got the makings of a pretty good nose.

### The Manga special
Popular with Anime fans and Manga Artists—very stylized and usually no nostrils, which makes it hard for your characters to breathe. You can make this version a little bit more realistic by adding some of the same details you did for the "7": nostril, bridge bend—nice nose.

## The Bent V

When light hits the face from above it forms a shadow under the nose which looks like a V—and this is a variation on that idea. By adding some details you can make this one pretty effective as well.

These are not the only variations you can use by any means—in fact you can mix and match to get some really interesting results. Try it.

Back to our face.

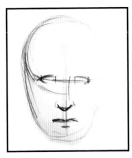

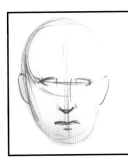

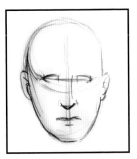

**Step 7:** Give the mouth line a flattened M. This is effective for a man's mouth because if you show the lips too prominently it'll make him look too feminine.

**Step 8:** Add a couple of bumps on the side of the head for the ears.

**Step 9:** Tighten up the jaw line a little bit and add a few lines inside the ear. This face is starting to come together.

**TIP** In your sketchbook you should make quick doodles of interesting hairstyles you see in public—you'll be able to refer back to these and it'll help immensely when you're trying to make your characters look unique. The last thing you want is all your characters walking around with the same hairstyle.

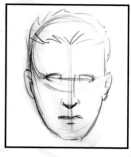

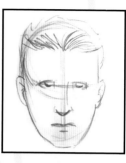

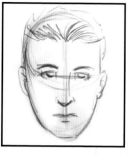

**Step 10:** Nothing adds variety to your character's face like hair (or lack of). Hair should be drawn in as a big shape as you flesh out the design.

**Step 11:** Start to work in the texture of the hair. Keep the lines going toward the face, so that the top remains open. This gives the impression that the hair is clean and shiny.

**Step 12:** Add eyebrows. Older characters usually have thicker eyebrows—but no matter their age, they should be thicker on the inside and taper out to a thinner line.

## Eye details

The pupils and iris are simple shapes, one circle inside a larger circle. A nice effect to show light reflecting is to draw another white circle on top of the pupil.

**STEP ONE:** Draw a circle in the eye area. It's a good idea to put about a fifth of it up under the lid. This gives it a more natural, relaxed look.

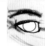

**STEP TWO:** Draw a black circle inside the outlined circle. This is your pupil. It should float about dead center of the bigger circle. Note that in this example a small portion goes up under the upper lid. If too much of your eye is exposed, it will make your character look surprised, or worse, deranged.

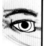

**STEP THREE:** Add a small dot of white—this gives the impression that there is light reflecting off the pupil, and will give your character a spark of life.

Looking at this example, you can see how taking the same details, similar head shapes, and altering the proportions, we can create three different characters who, since they share the same detail traits, look as if they could be related. This also demonstrates why it's so important to use a model sheet of your characters so you do use the same shapes over and over again to keep them looking consistent.

## Body proportions

Much like the variations with the head design, bodies are equally as diverse. Using a combination of different base shapes allows you to make all of your characters look unique.

**TIP**   No matter whether you are going to be working in a realistic, abstract, or cartoony style, every artist will benefit from a basic understanding of human anatomy. Check your area for life-drawing classes and open studios where artists get together to sit and draw models in different poses. You'll be amazed at how quickly you'll improve after just a few sessions.

**Step 1:** Let's start with some body shapes—look at this basic combination of shapes: lines, circles, and ovals.

Study the shapes and how they interact. These light pencil lines are called construction lines and are the base for all of your drawings; with them you are able to lay your drawings out first and correct any mistakes before you work on details.

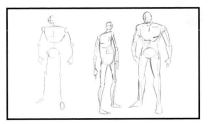

The base of this figure is similar to that of a wooden figure mannekin, available at any good art supply store.

Look at this diagram. Try to imagine all the circles on the figure as being ball joints; this will allow you to "pose" your drawing.

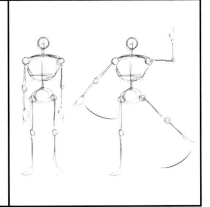

**Step 2:** Now let's take this figure design and relax it a little bit, change the angle slightly, and loosen the pose. See the difference? The first figure is too stiff—like an action figure still mint in its package. The second one looser, more fluid, more natural. We call this body language, and it deserves a whole section all to itself (don't worry—we'll get to it soon enough).

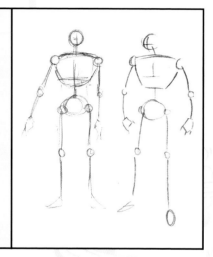

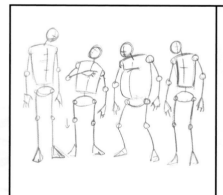

**Step 3:** Let's take these theories and try some different shape combinations to see what we can come up with: tall, short, fat, thin, heroic, scrawny, old, young—it's all a matter of putting these shapes together.

**TIP** Keep a small sketchbook with you at all times, then when you're in a public place you can make doodles of interesting people, faces, clothing, architecture, animals, and places. This will help you when you're back in your studio trying to draw from your imagination. You'll be able to refer to this sketchbook whenever you need it.

**Step 4:** After you do your figure layouts, you can start to bulk them up. The figure to the right shows a more "normal" type of body as opposed to the slightly exaggerated, bulkier hero figures to the left.

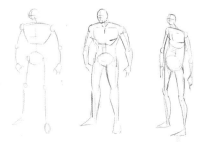

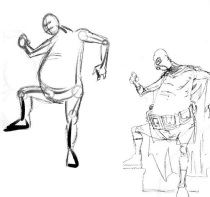

**Step 5:** Once you've got your figure worked out, you can add costume details, clothing wrinkles, and all the other little bits to make your characters fantastic.

With big, heavy characters, having their legs bend at the knees gives them a sense of weight. They have a lot of weight to carry so those knees get tired. It also works (as in this example) if the character is holding something heavy—like a big sword.

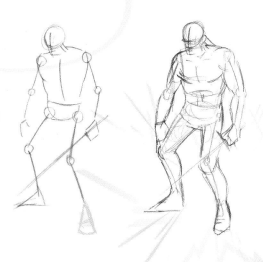

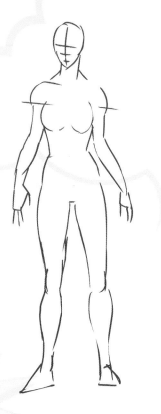

Women's bodies can be made up of the same types of shapes, but there are some key differences. Most important is the placement of the center point of the hips which is somewhat higher than a male figure's. The shoulders should be narrower and the hips a bit wider.

## Stereotypes in figurework

Sometimes using stereotypes in your graphic novel can help you to convey information quickly—heroic characters stand up tall, proud, and strong, while evil, villainous characters are hunched over and wicked-looking.

But going against stereotypes can make your work better. We all look at Superman and we get it—he's a good guy. Good looks, big smile, square jaw, swirl of hair blowing in the wind. He's tall and muscular, and looks like the kind of guy who saves the world every day.

But what about Batman? Dark and scary, hiding in the shadows. Big pointy ears and scalloped bat cape. If you didn't know who he was you'd probably think he was a bad guy. In fact, I think that's one of his biggest appeals.

As you design your characters think about making some big strong ones afraid of their own shadow, some small mousy ones super strong, and so on. It'll keep things fresh.

You can convey a lot of information when someone can take a look at your character and "get it." If you were making a graphic novel which used animals with human characteristics, it would make a lot of sense to choose ones that seem to "fit" their roles.

So it would make sense to have an eagle or a tiger as the leader of your group of animal commandoes in World War II. But that doesn't mean you couldn't substitute a turtle and get great results by going "against the grain."

Europe's great graphic-novel series *Blacksad* by Juan Diaz Canales and Juanjo Guarnido features people like animals in very film-nourished crime stories. This is a popular and perfect example of the use of animals with human characteristics in graphic novel drawing.

CINE ÉTOILE

ELLE NE RAYONNAIT PAS COMME UN ASTRE LA PREMIÈRE FOIS QUE JE L'AI RENCONTRÉE, BIEN AU CONTRAIRE, SON VISAGE NE REFLÉTAIT RIEN D'AUTRE...

...QUE LA PÂLEUR LA PEUR.

## Coming up with characters

Think it's all been done? That there are no more unique and interesting characters left to create in comics? Tell it to Hellboy.

When Mike Mignola was coming up with the paranormal investigator and reluctant hero he decided he wanted to draw something about a monster fighter so he could draw a lot of monsters—then he realized: if he made the protagonist a monster himself he'd get to draw monsters all the time.

**THE SCARLET PIMPERNEL + D'ARTAGNAN = ZORRO**

The best characters take elements from ones that have come before and combine them with others, while tweaking the details to keep everything fresh.

And yet, despite their similarities, each offers something unique to them, which makes them legitimate and fascinating characters.

**TIP** When creating your characters for your graphic novel it's crucial to create a model sheet.

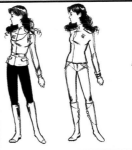 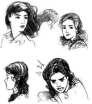

A model sheet is a drawing of your character, usually a full body shot with various poses as well as close-ups of the face using different expressions. It's used as consistency reference when you are drawing your character throughout your story.

Sometimes combining elements can help you create great characters. In the following exercise, take one element from each column and put them together to create a character; then design what you think he or she would look like. Flip a coin to see whether your character is male (heads) or female (tails).

| DESCRIPTION | BASE | FROM | MOTIVATION |
|---|---|---|---|
| Angry | Pastry chef | Mars | Vengeance |
| Insane | Adventurer | Undersea | Money |
| Ghost | Pirate | Cleveland | Curiosity |
| One-eyed | Actor | Russia | Lost |
| Happy | Superhero | Village | Justice |
| Wild | Chicken-man | New York | Power |
| Driven | Robot | The Moon | Love |
| Exhausted | Bounty hunter | Japan | Work |
| | | Bermuda | |

Now add in any two of these factors to your character's background

| | | | |
|---|---|---|---|
| Sidekick | Fancy costume | Big hat | Peg leg |
| Superpower | Big hair | Platform | Bad eyes |
| Very fat | Very tall | shoes | (thick |
| Good- | Very smart | Very ugly | glasses) |
| looking | Bald | Very dumb | Charming |
| Lisp | | Big feet | Handicap |
| | | | Odd pet |

Now try and create some model sheets for your own amazing characters.

# Chapter 3

# Features & quirks

**COLORING, INFLUENCE, POINTS OF VIEW—THESE ALL HAVE A ROLE TO PLAY IN MAKING YOUR GRAPHIC NOVEL UNIQUE AND INTERESTING**

# THE MANGA INFLUENCE

**J**apanese comics called Manga are extremely popular, not just in Japan but all over the world, so it's impossible not to feel their influence.

### The Manga cycle

**1.** In 1933 comic books are first published in the United States, mostly made from newspaper reprints. They become a phenomenon with the introduction of Superman in 1938's *Action Comics #1*.

**2.** Japanese creators are influenced by this new art form. In reality they've been telling stories using pictures for centuries, but this new form of "comic book" strikes a cord with artists such as Osamu Tezuka, who produces *New Treasure Island* in 1947 as a limited color book and it's a huge hit selling more than 400,000 copies. He follows this up with an adaption of *Crime and Punishment*, which is met with equal success.

In 1951 Tezuka introduces Astro Boy in his Captain Atom feature appearing in *Shonen* magazine and creates a sensation. This modern take on Pinocchio features a boy robot who can speak 60 languages and fire lasers out of his hands.

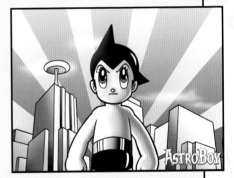

**3**. Manga is adapted into popular animated features and TV series; Astro Boy is one of the most popular, and when these cartoons are exported to the United States they are seen and enjoyed by millions.

**4.** Current American artists such as Paul Pope and Ed McGuinness

are all heavily influenced by Manga when they produce comic books in America, bringing the cycle of influence full circle.

Many modern Western graphic novels incorporate a few techniques commonly found in Manga storytelling such as:

## Speedlines

Since Manga are produced so quickly (they are generally published in weekly serial installments) many Manga artists use speedlines to add both dramatic effect and filler to their panels.

**Step 1:** The best way to use speedlines is to choose the area of your panel that you want to emphasize and draw an "X" in pencil at the center of it.

**Step 2:** Then (using your ruler) draw lines from the edge of the panel toward this center mark. After you've penciled in these lines, go over them with ink.

*TIP*　A great way to get varied line weights is to use a brush for speedlines. Inking with a brush takes practice, but inking straight lines with a brush can be really challenging. Take your ruler and hold it at about a 45-degree angle, then after dipping your brush in ink run it along—you've got a nice clean brush line.

# Panel breakouts

Used more and more in Western comics and graphic novels, this technique started with Jack Kirby in his comic work on titles like *Sandman* in the 1940s but took off with Manga artists.

By having the character break the panel it gives the reader a sense of great action, but you only want to use this technique on a very limited basis otherwise your page layout will be much too confusing.

*Captain America*, Marvel Comics

*Harker*, Andy Fish

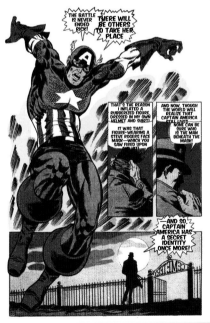

# Graphic novel styles

There are a variety of styles used in the art of graphic novels.

### Black and white

Either "clean" with stark blacks and whites or with a gray "wash," tones, or textures.

### Limited color

An effective technique using only one or two additional colors (as well as black and white). This creates a very "artsy" style.

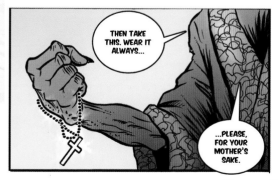

### Full color

Color can play an important role in setting the mood of your story. A good colorist is an artist too and understands how certain colors affect the way you feel when you see them.

For example, a panel colored with mostly blue tones give the panel the feel of a night-time setting.

An emphasis on reds conveys a sense of heat, anger, or even stress.

Even traditional coloring adds to the dimension of the artwork when it's done well.

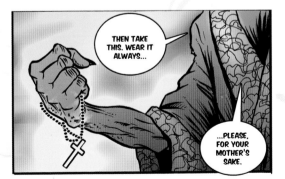

## Effective techniques in coloring

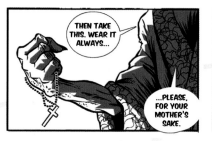

### Black and white wash

Done using the slightest amount of ink with a wet brush, sometimes even using the dirty water you wash your brush off in, to create a gray wash.

### Black and white dots

Adds gray depth in a very graphic designish way.

### Black and white cross

Crosshatching goes back centuries, and was especially popular in illustrations from the Victorian age of newspapers. Its clean series of lines crossing each other is very effective in creating gray tone.

### Limited color off-registration

By not having the color line up perfectly with the black line art you give the feeling of a silkscreen print.

## Color shadow

Adding a degree of darker hues on top of your coloring gives your panels a sense of form.

## Color off-registration

Same as limited color, but when done with full color you give the impression of an old-fashioned comic book page where the print registration wasn't always perfectly aligned when it was printed.

# Graphic novel points of view

Graphic novels, comic books, and movies are very closely related. In fact, many great directors such as Tim Burton and Alfred Hitchcock were accomplished cartoonists who often drew out difficult scenes in their films before they went before the camera in comic-strip-like pages called storyboards.

Many successful graphic novelists have either studied film or are big film buffs, incorporating the best of film techniques in their work.

As you are laying out your story you need to decide things such as panel size, page layout, and camera angles as you arrange the elements on your page, making sure the story you are trying to tell is both clear to the reader and exciting.

### Worm's eye view
The "camera" is set on the ground and shows what a worm might see from an extreme low angle. This is effective if you're trying to show the size of something or attempting to make someone look intimidating.

### Bird's eye view
The opposite of a worm's eye view, the bird's eye view gives a look at things from above—an effective way to show a large area or to help set the action.

## Over the shoulder

A nice way to demonstrate a conversation without choosing the more boring side-to-side shot. Try to think like a film director looking through a camera lens as you're laying out your panels—and position your "actors" to stage your shot in an interesting manner.

## Point of view

Shown from one character's point of view. Nice to show something shocking or to make sure your reader gets an important plot point. Can also be used to show someone looking with binoculars or through a telescope.

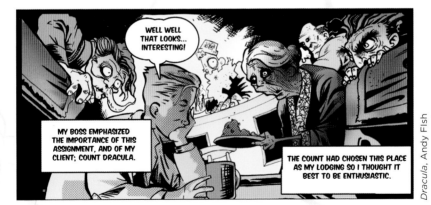

*Dracula*, Andy Fish

## Medium shot

A good way to establish where your characters are in relation to each other. It shows characters usually from about mid-thigh up.

## Close-up

Nice when you want to show a character's reaction, or how he or she is feeling. It's a good idea to vary your shots a bit so that things don't get stale.

## EXTREME CLOSE-UP

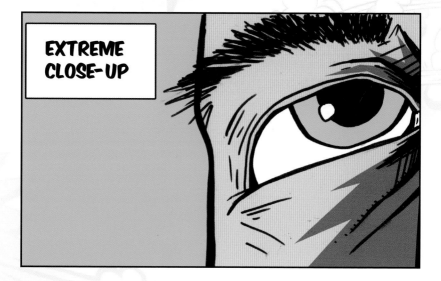

## Extreme close-up

Camera gets in really close. This is used to show a great deal of surprise or emotion.

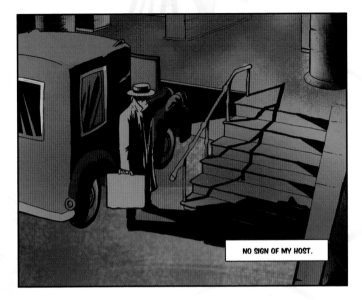

## Long shot

Generally used as a straightforward way to establish where a character is and what the setting might be.

## Full shot

Used to show the full figure of a character. It is important to give your readers a look at the character they are reading about.

# Chapter 4
# Storytelling

THE ART OF STORYTELLING AND PAGE COMPOSITION IS AS CRUCIAL AN ELEMENT IN GRAPHIC NOVEL DRAWING AS GIVING HISTORY AND LIFE TO YOUR CHARACTERS

# PANEL COMPOSITION & PAGE LAYOUTS

age layouts and panel compositions are essential components of the graphic novel and should be considered before you begin drawing.

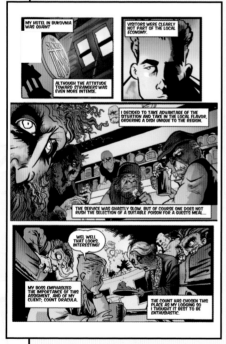

Gutter spacing

Panels are the boxes that hold the pictures on your page. The area between them is called the gutter. It's important to make sure that you either leave a good amount of space in your gutter, or you clearly define your panel borders to keep things easy to read and follow.

The artist must know the placement of dialogue and the elements of the panel that are important to ensure proper "flow."

# The panel flow

Panels are read top to bottom, left to right, so your design should understand this and work to incorporate it. Let's look at this example.

**1.** You begin at the top left, so the first thing you see is this oddball peeking at the hero as he sits in a booth in the pub.

**2.** This takes your eye to the first narration box on the panel.

**3.** As you pass the lead character you note his expression and you read his dialogue balloon.

**4.** Going down the panel you see the food he's referring to and this takes you past the old woman serving him to the next narration box.

**5.** You read the box and then head up the panel.

**6.** This takes you off the panel comfortably leading you to the other oddball character watching him. You get the sense that he is a person of interest.

As the writer of the story, you need to consider things such as who is talking first when you choose panel composition. You don't want to have a layout such as on the right.

A confusing panel layout leads your reader all over the place, not letting them know where to go next and causes them to be removed from the story while they try to figure their way through it.

Look at the example above: it looks like the character on the left is a mind reader and answering the other character's question even before it's asked. The artist is making the reader start at the upper right of the panel—and that's just not how it's done.

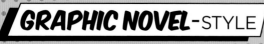

If we attempt to work out this problem we can approach it a couple of different ways. Remember panels are "read" just like a paragraph of words— left to right, top to bottom.

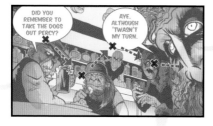
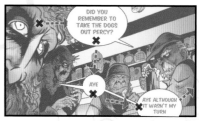

**Step 1:** Flip the panel layout. This might not always be an option— especially when it comes to staging your characters—and this goes against the way the artist drew the panel. But the benefit is that it is easier to read and at least you can tell who's talking first.

**Step 2:** Or utilize the strength of the panel when incorporating your balloons. Because this panel features a close-up of the character on the left and plenty of dead space, there is room to move the balloons around. Still not ideal but it's probably the best option. This is a good example of why figuring in balloon placement in your thumbnails (see page 56) is a good idea.

## Staging

Staging your panel layouts is a lot like positioning your actors in a movie—you have to decide where each character is going to "stand" in your panel.

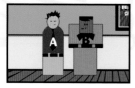

Figure 4.1                     Figure 4.2                     Figure 4.3

If you take two characters and stand them side by side (Fig. 4.1) you end up with a fairly boring shot—or something you might see in a comic strip—far from the effect a graphic novelist would want to go for.

If you take the same basic setup but move character A forward a bit (Fig. 4.2) you end up with a more interesting composition because now the characters don't seem to be standing in a line.

In the next example (Fig. 4.3) I've moved character A closer still. Now he's almost on top of the reader—and this is effective in conveying the drama of a conversation.

Figure 4.4

A variable of that is to move both figures closer (Fig. 4.4), which gives a tighter composition. All of these elements can be (and should be) used together when designing a series of panels.

Figure 4.5

There's no rule that says the characters always have to be facing you—it's okay to have the character closest to the viewer with their back to you (Fig. 4.5). This gives the impression that they are involved in the conversation.

## Balloons and speech bubbles

While on the subject of balloons, let's look a little closer at this aspect of graphic noveling.

As wonderful as your art is, the whole thing becomes an unreadable mess if you can't make out the lettering in the balloons. More and more graphic novelists are turning to the computer to handle their lettering needs, and two great resources for comic style fonts are **www.dafont.com** and **www.blambot.com**. Whatever you do, if you letter with the computer don't use Comic Sans—it just looks bad.

Balloon design is an art all by itself. A clean and well-spaced balloon makes it easier to read.

The type of balloons you use and the way you handle the lettering are a language in themselves.

There are also some advanced techniques including balloon chains, interruptions, and sound effects:

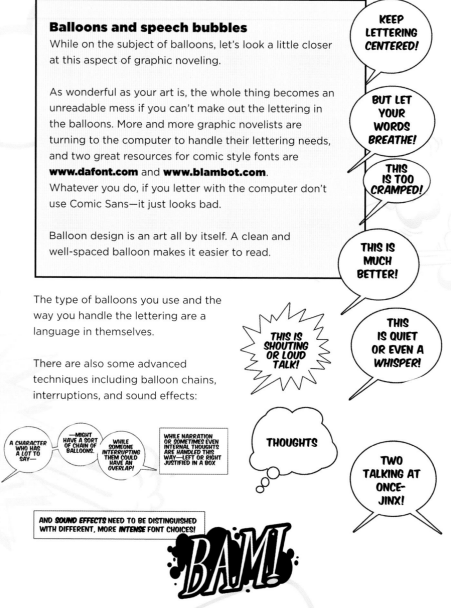

KEEP LETTERING CENTERED!

BUT LET YOUR WORDS BREATHE!

THIS IS TOO CRAMPED!

THIS IS MUCH BETTER!

THIS IS SHOUTING OR LOUD TALK!

THIS IS QUIET OR EVEN A WHISPER!

A CHARACTER WHO HAS A LOT TO SAY—

—MIGHT HAVE A SORT OF CHAIN OF BALLOONS.

WHILE SOMEONE INTERRUPTING THEM COULD HAVE AN OVERLAP!

WHILE NARRATION OR SOMETIMES EVEN INTERNAL THOUGHTS ARE HANDLED THIS WAY—LEFT OR RIGHT JUSTIFIED IN A BOX

THOUGHTS

TWO TALKING AT ONCE—JINX!

AND *SOUND EFFECTS* NEED TO BE DISTINGUISHED WITH DIFFERENT, MORE *INTENSE* FONT CHOICES!

BAM!

# Page layout and design

Most successful page layouts are based on a six- or a nine-panel grid.

If you look at comics from the 1940s through the 1960s they were all laid out this way. It kept things easy to read. It wasn't until the 1970s that artists started looking at the page as a whole and began going for a more dynamic look.

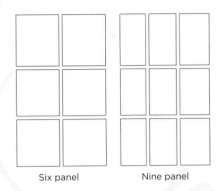

Six panel          Nine panel

Finding the grid system a bit old fashioned, many modern artists have learned to experiment and adapt while still following the basic outline of the grid to keep reading clarity. See how Steranko pushes the boundaries of the panel grid layout:

*left: Spider-Man, Steve Ditko right: Nick Fury, Jim Steranko*

Figure 4.6                    Figure 4.7

Fig 4.6. shows a page laid out using a nine-panel grid as a base, while Fig. 4.7 shows a six-panel grid layout. An artist can use virtually any combination to create a dynamic and exciting page that is still easy to read and understand.

The next thing you need to understand about page layout is the rule of the lazy Z. To put it simply and visually, read through the page, then look at

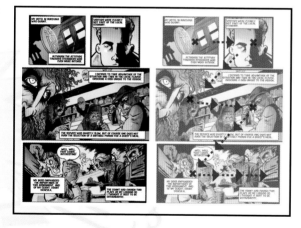

the diagram which tracks your eye—or at least the way your eye should go if I did my job right on the page shown left. Notice that the track makes up a series of Z shapes as your eye bounces back and forth from left to right. The images and the balloons on the page recognize this pattern and fall into step with its key elements. Arranging your well-thought-out panels is key to a successful page layout. A solid page layout tells your story dynamically and is clear in its storytelling. I can't emphasize enough how important this is.

Too often artists sacrifice readability for an exciting page layout—sometimes considering the after-market value of the artwork at the expense of keeping a clear and readable story—but with a bit of thought and some strong prep work you can have both. Successful page layouts in graphic novels work the same way.

Thumbnails, which are small versions of your final page, are the key to a successful page design. Some artists like to work small, usually 8 x 10in (20 x 25cm), while others prefer to work larger; Neal Adams, for example, works at 11 x 17in (28 x 43cm) and then enlarges the thumbnail and traces it onto his illustration board with a lightbox. The thumbnails often capture an energy at the smaller size that is difficult to translate without a direct trace.

**PAGE DESIGN**

## Three layouts of a page

**1.** The layout on the left utilizes the full body panel break technique. This is effective for establishing the look and style of a character while continuing your story.

**2.** The one in the center features an establishing shot—an important storytelling technique I address on page 160—of a group of buildings while with the second panel you zoom toward one of those buildings. Following that is a close-up of (you assume) someone inside one of those buildings drinking a cup of coffee. The final panel combines an over-the-shoulder shot with an open panel design to keep the page design fresh.

**3.** The alternative to the traditional straight panel borders is the floating panel design (used extensively by Will Eisner in his later graphic novels). This gives a bit of a dreamy attitude toward the storytelling. One thing is critical: your page design must present clear and understandable storytelling, because telling the story is what this is all about.

## The Thumbnail process

**Step 1:** Decide on your thumbnail size—whether you want to work large or small. Some artists go to the length of having pre-printed boxes made up on sheets of regular letter-size paper.

**Step 2:** Read your script through, then read it again. Making note (use highlighters) of important scenes, shots, and details.

**Step 3:** Now begin drawing out your pages in thumbnail size. Don't get too detailed because you're going to be drawing these again larger and you don't want to get bored drawing the same thing over again.

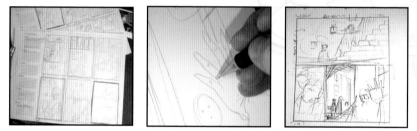

**Step 4:** Sometimes you might have to draw and redraw the same page when you are trying to figure out difficult sequences.

**Step 5:** Once you are happy with your thumbnails you can scan them into the computer and enlarge them or do it on a regular photocopier.

**Step 6:** Lightbox your thumbnails onto a sheet of bristol or art paper and clean up your pencils. You now have a fully penciled page ready to go.

## The Lightbox

You can buy a commercially made lightbox at most art supply and craft stores for a reasonable price. You can also craft your own lightbox by placing a lamp

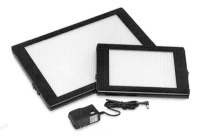

and craft stores for a reasonable price. You can also craft your own lightbox by placing a lamp underneath a glass table or you can get a piece of translucent lexan or lucite at any home improvement store cut to whatever size you want, then prop it between two chairs with a lamp between—and you have an instant lightbox.

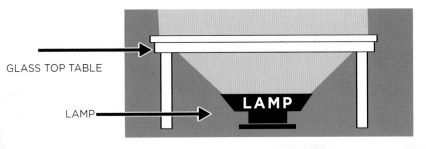

GLASS TOP TABLE

LAMP

**LAMP**

Many artists factor in the dialogue that is being spoken in a given panel as they do their layouts too. Jules Feiffer, a very famous writer of both comics and prose novels, often did his entire script in thumbnail form including all of the dialogue, which he would then give to his collaborative artist to draw their pages from. This is a huge benefit and eliminates the problem of trying to "fit in" the word balloons.

# Chapter 5
# Enhancing techniques

BY INCLUDING SPECIAL EFFECTS AND WORKING WITH TONES, ENHANCING TECHNIQUES GIVE EXPRESSION TO YOUR CHARACTERS AND MOVEMENT TO YOUR ACTION

# SPECIAL EFFECTS

**T**here are several techniques you can use to enhance your graphic novel storytelling. These are called "special effects."

Much like sound effects and computer-generated imagery (CGI) in movies, graphic novels use a series of visual tricks and techniques to enhance the storytelling process.

**1. Speedlines** These lines, which point to the centerpoint of action in your panel, are discussed in depth in Chapter 3 (see page 40).

**2. Burstlines** Similar to speedlines, these usually show an extreme force or action—such as an explosion.

**3. Motion lines** Lines that indicate something is moving. They can be straight lines to suggest speed or on either side of an object to indicate motion back and forth or shaking.

**4. Motion blur** Often used to indicate something is moving crazy fast.

# Foreshortening

The ability to foreshorten is imperative in giving your work a dynamic look. Let's walk through the process.

Look at the shapes used to make up an arm. There are circles for the shoulder, elbow, and wrist—anywhere on the body that can bend. These "ball joints" help you with keeping the proportions straight on the body as you draw it.

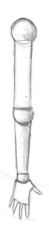

In-between these joints we use cylinders (Fig. 5.1) to represent the upper arm and forearm and then give a kind of loose shape for the hand.

Figure 5.1

Let's look a little closer at a cylinder. When it's laid flat it appears flat, but if we raise it up toward the viewer it looks more like Fig. 5.2.

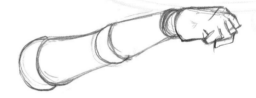

Figure 5.2

Take the shapes we used to make up the arm, think of them as cylinders... and raise them up toward the viewer: we end up with this (Fig. 5.3).

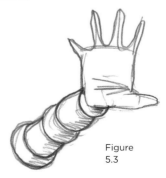

Figure 5.3

The body works the same way. From the front it looks like Fig. 5.4, but when we tilt that angle as we did with the arm it becomes a series of shapes put together like Fig. 5.5.

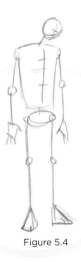

Figure 5.4

Using this same theory we can then do virtually any pose, and this creates an amazing array of action positions.

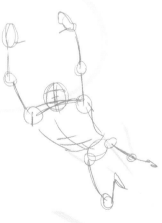

Figure 5.5

## Weird but true

Manga artists use a lot of really strange special effects techniques, and more and more Western artists are starting to use these styles to tell their stories.

SOME OF THE STRANGER ONES:

### Blank eyes

This technique is used to demonstrate that the character is acting or pretending. It's supposed to convey a sense of falsehood to the character's actions.

In the West this is often mistaken as the character being possessed, although you could argue that he or she has been possessed by the performance they are putting on.

### Starburst

This little effect represents a throbbing vein in someone's forehead. In extreme circumstances it can also be drawn floating up above someone's head—to indicate that their whole head is about to explode.

### Nose bubble

This one might be the strangest of all. The nose bubble is usually used along with a series of ZZZZzzzsss—because it indicates a character is in deep sleep.

### Nose bleed

Called Hana-ji, this is a demonstration of sexual lust and might be too bizarre for use in Western graphic novels.

### Super sweat

Not just a Manga technique—in fact it's used quite a bit in popular European graphic novels like *Tintin*—the super sweat is just as the name implies, a representation of extreme tension and stress.

### The water works

Used to make it appear that a character is crying so hard that they've turned on a virtual waterworks, which flows down the character's cheeks. Can be combined with a runny nose to emphasize the effect.

### The steam machine

Steam blowing out of either the top of a character's head, or out of both ears. This is used to show that a character has virtually blown their top.

## Applying tones

Tone is the effect of adding gray to black and white artwork, enhancing the artwork by emphasizing form, mood, or shadow.

There are several methods for creating tone:

**1.** Using sheets of mechanical tone available at most art supply stores.

**2.** Using the gray wash water, which is created by dipping a paintbrush into a small cup of water mixed with a very small amount of ink.

**3.** Applied using a computer program (such as Photoshop).

See the difference? Nicely placed tone can give the work a polished look, and it also creates a sense of form on your artwork, keeping it from looking too flat.

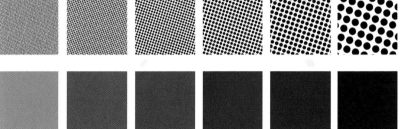

First let's look at the effects achieved by adding tone (above).

The degree of gray achieved is based on the ratio of black to white. These tones are sometimes made out of a series of screened dots and the amount of space between them determines the value of the gray color.

Keep in mind that when printing, it is normal for grays to appear slightly darker (usually 10%) than what you might see looking at the original art. Therefore you should always fall back 10% in setting your value. So if you want your printed art to appear with a 40% tone, you should apply a 30% tone on your page. Note too that anything above 80% might as well just be black since you probably won't see any difference when it's printed.

# Working with tones

There are different ways of applying tone. The method you choose should be based on the effect you want to create.

## Tools you will need

Mechanical tones, sometimes referred to as Zip-a-tone, which was a brand popular in the 1960s in graphic design, can be bought in most art supply stores or online (see the resources section on page 209 for recommended art suppliers). These sheets come in different tone values and are either adhesive or rub down, so you'll need some tools to work with them.

**1.** Sharp scissors

**2.** An Xacto or razor blade (if you're using adhesive tone sheets)

**3.** A hard pencil 2H or 4H (if you're using rub-down tone sheets)

**4**. A clean area to work in

**5.** Tracing paper (optional)

**6.** Clear acetate sheets (optional)

**7.** Patience

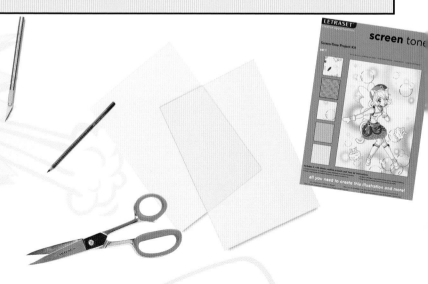

## Using a pencil

**Step 1:** Lay out the art page you want to apply the tone to. Sometimes a sheet of tracing paper is a good resource to figure out the possible placement of your gray areas. If you're using adhesive tone sheets you can also opt to apply it to a clear sheet of acetate and create a gray overlay—which eliminates the possibility of mistakes that might ruin your art.

Work economically. Don't just lay the tone down and start cutting. You want to make the most of every sheet because it can get expensive, so make it fit into what you need by starting from the edges of the tone sheet and save your scraps.

**TIP** Dirt is the enemy of applying tones. Make sure your hands and your work area are clean and you'll save yourself a lot of trouble.

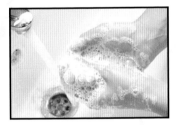

**Step 2:** Place the tone over the area where you want it on the page and use your Xacto—make sure it's a sharp fresh blade—to remove the areas you don't want. Score it—don't cut it—because you'll cut right through your artwork.

**TIP** Experiment with the tone on a scrap piece of art before you work on the "real" finished art. It is better to make a mistake on a sketch that you've worked on briefly than on the masterpiece you have spent hours on. Get yourself comfortable with the process this way.

**Step 3:** If you're working with rub-down tone, use your hard pencil (at least a 2H or, better, a 4H) and a hard flat surface, and burnish the area where you want the tone to appear. Be careful not to rest your arm or palm of your hand on the sheet because it will cause the tone to apply where you don't want it to—and you'll end up with a very messy page.

## Drawing tones

Tone effects can also be added by hand using linework or crosshatching or wash, which is watered down or thinned black ink. No matter how the gray is applied to your page it will be converted to dots in the printing process.

### Crosshatching

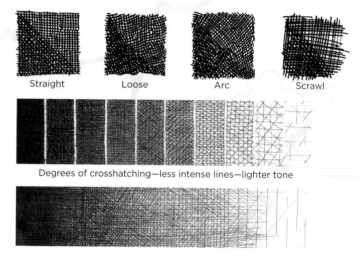

Straight          Loose          Arc          Scrawl

Degrees of crosshatching—less intense lines—lighter tone

Adding inkwash with a brush can give the art a great extra quality and offers a more fluid line that you can't get with mechanical processes.

## Computer effects

Welcome to the twenty-first century. Most artists now use Photoshop or other art programs to apply gray tones to their art. It's clean, works great, and completely eliminates the chance for error since everything done can be undone—plus it's about a million times faster.

**Step 1:** Scan your artwork into your chosen computer program at 300dpi as a grayscale image.

**Step 2:** In Photoshop you can add a layer over your artwork and then fill that layer with a gray color using the paint bucket tool.

**Step 3:** Go to Filter> Sketch> Halftone pattern and see what you can achieve when you experiment with the settings. You can also go to Filter> Pattern maker and do much the same thing. (Some artists even scan in sheets of tone and then use the cut and paste tool to add it to their pages.)

**Step 4:** Now using either your Wacom tablet and the eraser, or the polygonal lasso tool, you can remove all the gray parts you don't want—and soon you will have an effectively toned page.

## Tone effects

The goal of adding the tone can vary from artist to artist and from project to project.

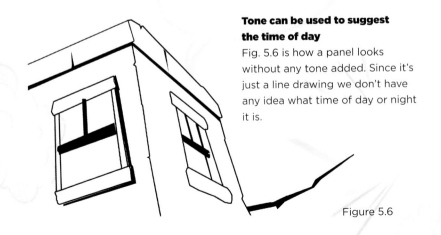

### Tone can be used to suggest the time of day

Fig. 5.6 is how a panel looks without any tone added. Since it's just a line drawing we don't have any idea what time of day or night it is.

Figure 5.6

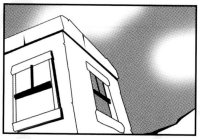

Figure 5.7

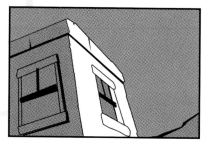

Figure 5.8

Figure 5.9

Fig. 5.7 shows the same line art drawing but with some tone added to suggest a cloudy midday sky. Taking the same base I've added a bit more dark tone to the building itself as well as the sky, suggesting a time later in the day (Fig. 5.8). Increasing the amount of tone in Fig. 5.9 gives the impression of night.

When adding tone to suggest the time of day, it's important to predetermine the light source before you do the application. It's not enough to just drop a tone all over the page—that wouldn't be as effective.

Determining light source is simply a matter of being a shadow detective. Let's take the bottle in Fig. 5.10. It's got a tone applied to it to give it a sense of form, but by dropping a shadow on it we can see that the light is being cast from above and to the right (Fig. 5.11).

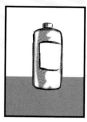

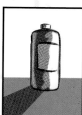

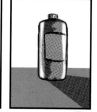

If we reverse the shadow direction it also reverses the heavier shade on the bottle itself (Fig. 5.12). It's just a matter of thinking things through.

Figure 5.10          Figure 5.11          Figure 5.12

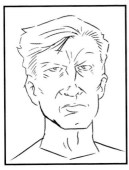

**Step 1:** Let's start with the line drawing like we did with the building on the opposite page. It's a perfectly good line drawing but it has a kind of coloring book feel to it.

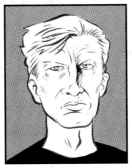

**Step 2:** Adding blacks to the hair and a gray tone to the background as well as a bit of shading on the face enhances the image.

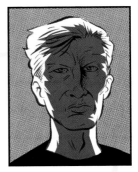

**Step 3:** Adding a shadow to the front of the face adds an air of mystery. This would indicate that the face is being lit from behind.

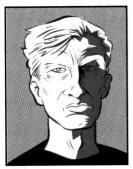

**Step 4:** A shadow set strongly on one side of the face gives a sense of strong offside lighting and creates a sense of mood.

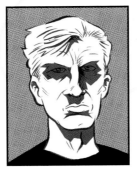

**Step 5:** A strong light directly above the face will create a heavier shadow in the eye sockets, and under the nose and chin, giving a sense of menace.

**Step 6:** Setting the light from below gives the effect of discovery or higher power.

# Chapter 6

# Inking
# & color

COLOR AND INKING ARE CRUCIAL ELEMENTS OF YOUR DRAWING. TONE, COLOR DENSITY, AND USE OF COMPLEMENTARY COLORS ALL HAVE A ROLE TO PLAY IN HOW YOU TELL YOUR STORY

# TEXTURES & SHINES

**T**exture is used by the artist to convey the "feel" of the subject, not just its form and color. Shine affects the depth of your image as well as its texture.

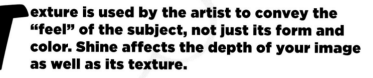

## Tools you will need

**1.** Brush (recommend #2 round synthetic)
**2.** Ink (India ink)
**3.** Cotton swab
**4.** Old dried-out sponge
**5.** Liquid frisket
**6.** Dry pencil or China marker
**7.** Permanent markers—fine line and broad line
**8.** Quill and nib

# Inking

This requires a great deal of experimenting—only by try and fail methods can you discover techniques to create amazing texture and shines.

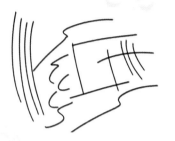

Most of us are very comfortable working in pen. The trouble with most pens is they are not archival even if they say they are. In the course of time the black inks will turn brown or purple.

But a pen can give you some pretty good lines. When you are ready to "ink" your pencil artwork, the first step is to trace over the pencil lines you want to keep, ignoring any mistakes and missteps.

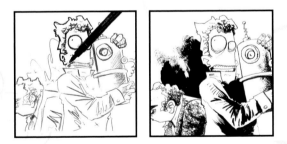

When you're finished you can then go ahead and fill in your large black areas and shadows—in this example the black in between the two characters is applied using an old dry sponge.

## Pens

These are great for lettering too—and they come in a wide variety of sizes from 0.005mm all the way up to 0.10mm.

There are also pens that have a brush tip, called brush pens. These combine the comfort of a pen with the great line of a brush. They do take a little getting used to, but with practice they can be an invaluable addition to your art supplies.

## Quills and nibs

Also called dip pens, quills are effective in creating lines that are both thick and thin and offer greater control than a brush and more permanent ink than a disposable pen (because you can choose the ink you use with a quill).

Quills do take some practice, and there are some basic rules to using the quill.

**Step 1:** When you dip the pen into the ink you only want to get ink on the lower part of the nib. It should never get on the handle because that means you are dipping it in too far.

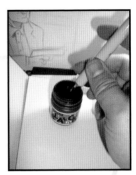

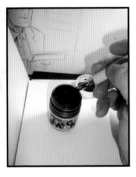

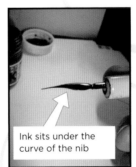

Ink sits under the curve of the nib

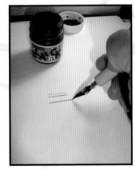

**Step 2:** As you pull the pen out of the ink you should wipe the quill on the edge of the bottle lip to get the excess ink off.

**Step 3:** The ink on a quill sits under the curved part of the pen. Therefore, always hold the pen so this area (the undercurve) is facing the paper.

**Step 4:** Pull the pen toward your hand. It's a good idea to have a piece of scrap paper to start on because you want to get the ink flowing. Once it starts you'll get a smooth ink line flow.

**TIP** Sometimes there is a wax coating on the nib when it's shipped. You might have to hold the nib over an open flame or under hot water to remove the wax.

 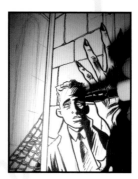

Quills are excellent for doing small details and backgrounds too.

**Step 5:** You don't want to bear down too hard— you should be delicate when using a quill. If you apply a little bit of pressure you'll get a thicker line, so experiment with some scrap paper.

## Brushes

There is nothing like a brush for giving you a wide variety of lines. Most of us start out using only a pen to put down the black areas on our art—and some seasoned pros still work only in pen—but for effect, beautiful linework, and speed you cannot beat a brush for applying inks.

**Step 1:** Take a scrap of paper—preferably the same type of paper you are drawing your graphic novel on. Then dip your brush into the ink—this is actually more complex than you might think (see opposite).

**Step 2:** Wipe the excess ink off your brush onto the lip of the bottle and try dragging the brush along the paper. Try using a very light and delicate line, then a heavier and darker line, then try combining the two. Begin lightly and then bear down, then go back to the delicate line and you should have something like Fig. 6.1.

This beautiful line can be used to show form when you are inking your objects—try doing that with a pen.

Figure 6.1

**TIP**  When you dip your brush into your ink bottle you want to make sure that the bristles of the brush never touch the bottom of the ink bottle. There is ink sediment down there and that will clog up your brush. You should also never get ink onto the metal part of your brush head—you're dipping it in too far if you do—because that will oversaturate the bristles and cause them to wear out quicker.

Cleaning your brush properly is also vital:

## Washing
**Step 1:** Put a little bit of warm water and soap in your hand—keep the water running (make sure it's warm).
**Step 2:** Take your brush and gently rub it from bottom to top only in the water in your hand. You should go with the direction of the bristles and never against them.
**Step 3:** Continue this procedure, slowly turning your brush in your hand as you go so you are able to get all sides of it.

**Step 4:** Hold the brush under the running water for a second. Rinse your hand out and then put some clean water in it.

**Step 5:** Repeat the procedure with the clean, clear water. If it starts to turn black or gray then you still have ink on your brush and you'll need to keep washing it. Once the water stays clear you are ready to dry.

## Drying

A well-cared-for brush will last you for years. Dry your brush carefully using kitchen paper.

# Textures, tones, and shadows

You'll want a few different-sized brushes—some for working small details and others for filling in large areas of black on the page.

You begin with the pencil stage, working in as much detail as you can. The more you work here and get it all "down on paper," the smoother the inking will be. Don't leave too much to "fix" in the inking stage.

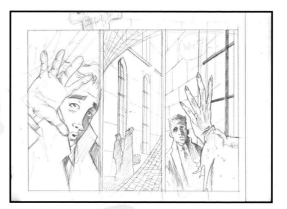

 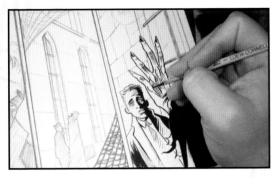

**Step 1:** Start by using your quill to outline the lines of the drawing.

**Step 2:** Continue working until all your linework is done. The images look like something you'd find in a coloring book. Now we're going to add textures, tones, and shadows.

**Step 3:** There are a variety of tools you can use besides just a brush and pens for putting down ink. A regular pencil can create great "energy dots," while a chopstick can put down smaller and tighter ones.

***TIP*** You can even sharpen your chopstick in a pencil sharpener to get finer dot tones.

A cotton swab can give you some beautiful "dry brush" effects.

### Liquid frisket

This is an invaluable tool for masking areas of the page that you don't want to ink. The process of using it is fairly simple.

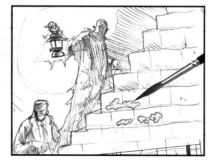

**Step 1:** Shake the bottle up, pour a small amount into a small cup—you don't want to work right out of the bottle because you may contaminate the frisket with residue from your paper and brush. Using a new clean brush (you should have a brush just for working with frisket) apply it as you would ink—only working in the areas you want to remain white.

**Step 2:** Allow the frisket to dry for several hours or even overnight. Then ink the page as you normally would.

**Step 3:** Once the ink has dried, you can peel up the dried frisket with your fingers, or you can use an eraser to rub it off, to reveal the clean areas you masked off.

There are several techniques for creating textures:

**1.** Plastic wrap—dipped lightly—can create a nice gritty feel for floors or walls.

**2.** An old dried-out sponge or cotton swab can create the effect of leaves or shrubbery (or even hair).

**3.** If you want to create the sense of something made of clean shiny metal, use your brush to do some loose zigzaggy shapes.

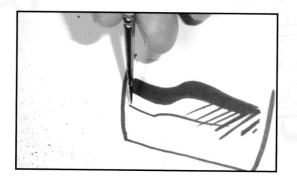

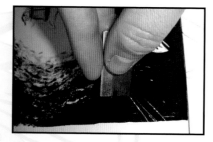

**4.** A razor blade can be used to scrape across an inked area to create the appearance of rain, or it works great to depict an explosion, or to put the details in a spider web.

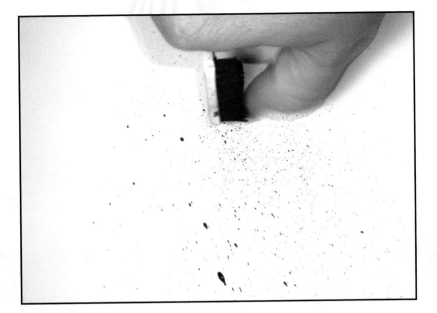

**5.** An old toothbrush dipped in ink and then gently rubbed with your thumb can make a great pattern of ink splatter. Just be careful to either use frisket or scrap paper to mask off the part of your paper you don't want to mark. This job is messy so wear old clothes.

The key is to experiment with different tools creating different marks—you'll never know what you can use.

## Applying colors

Color sets mood and adds a whole dimension to your work. Color can instantly convey emotion to a scene.

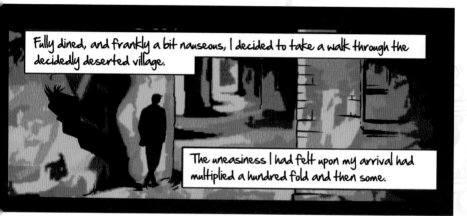

Fully dined, and frankly a bit nauseous, I decided to take a walk through the decidedly deserted village.

The uneasiness I had felt upon my arrival had multiplied a hundred fold and then some.

Blue

Take these three examples of the same scene colored in different colors. See how the color affects the mood of the scene and creates a different atmosphere.

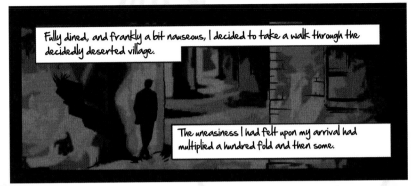

Fully dined, and frankly a bit nauseous, I decided to take a walk through the decidedly deserted village.

The uneasiness I had felt upon my arrival had multiplied a hundred fold and then some.

Red

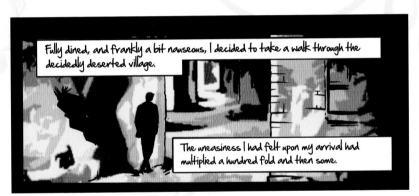

Fully dined, and frankly a bit nauseous, I decided to take a walk through the decidedly deserted village.

The uneasiness I had felt upon my arrival had multiplied a hundred fold and then some.

Yellow

Good coloring is more than just filling in the colors the right way—it's about adding to the atmosphere of a scene.

**93**

To be successful at coloring you must first understand some basic principles of color.

## Complementary colors

This refers to the fact that opposite colors intensify each other.

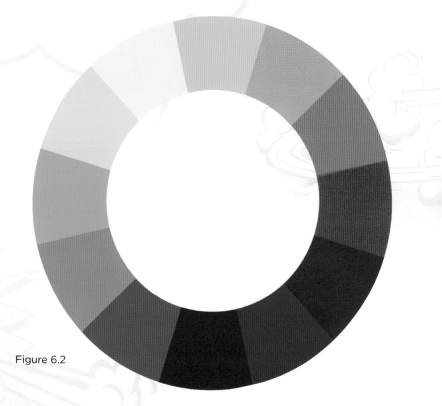

Figure 6.2

In the color wheel above, you can see that the opposite of green is red, blue is orange, purple is yellow, and so on. You can test this theory by choosing to invert a color image, which will show you the opposing color.

You may wonder how this benefits the graphic novelist.

Let's look at this illustration.

Now, if we color this main figure in yellow and then keep the background area in a state of orange, the figure kind of fades into the background because these are related color values.

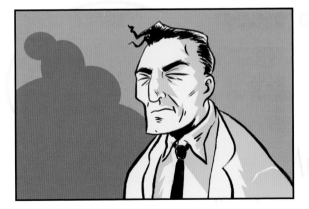

However, if we take the same image but make the background colors a light shade of purple you can see that the main figure now jumps off the page—due to the benefits of complimentary coloring. This simple action helps to set the figure out from the background.

## Hue

Hue is the value of the color of a given object. A pumpkin is orange, an apple is red, a banana is yellow, etc. Simply put, it's the first thing we think of when we imagine the color of an object.

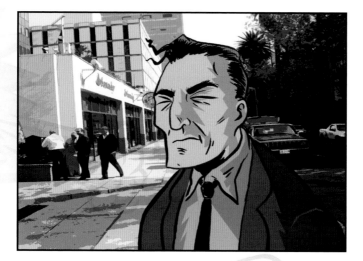

### Value

Value is the lightness or darkness of a given color. Take blue for example. Think of blue. Did you think of light blue? Medium blue? Dark blue? Value is another way of referring to the shade of a color. If your main image features all dark values then you should consider softening (or lightening) your background color to avoid the image looking muddy.

Value applies to color the same way gray applies to black and white. There should be a variety of value to your pages to keep them from looking too flat.

## Temperature

This refers to warm or cool colors. Reds, oranges, yellows are all warm colors. Think of the colors of summer.

Blues, greens, and purples are all cool colors. Think of the colors of winter or night.

Using this theory it's easy to create a sense of mood in your pages by ensuring you follow the temperature theory.

## Intensity

This refers to a color's chroma—the amount of color. A color that is 50% red would be an intense red, while a color that has 25% red and 100% yellow would be a medium orange.

Mixing the ingredients of color changes the intensity of the base color.

**Primary colors**

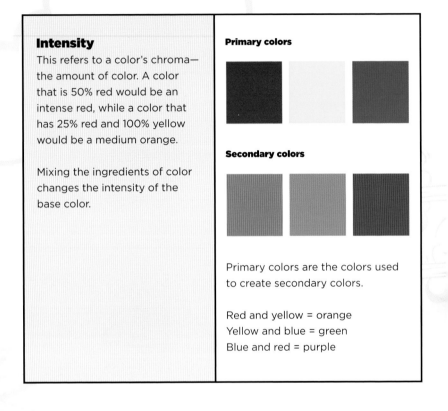

**Secondary colors**

Primary colors are the colors used to create secondary colors.

Red and yellow = orange
Yellow and blue = green
Blue and red = purple

## Saturation

This is how much color, or ink, you are using on your page. A piece of art with heavy color saturation can appear muddy, causing details in it to be lost.

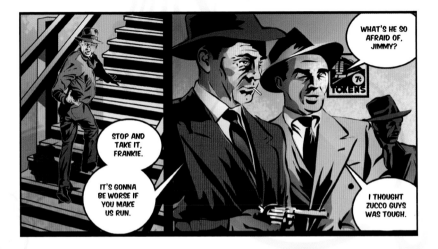

A page with moderate saturation is a better choice to ensure that the mood is set and we haven't lost any page details.

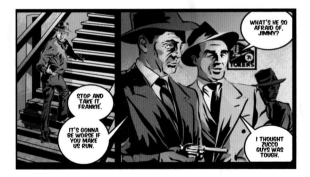

If too little saturation is used, the page can look washed out and faded.

This is hard. But who said coloring was easy?

## Using color to change the scene

An effective way to show your reader that you've altered settings is to change the color palette.

If a scene is taking place with heavy yellows switching to one with heavy blues, it is clear (sometimes subliminally) that you are looking at something different:

**Depth**

Think of some far-off landscapes you've seen. The mountains in the distance seem to fade into the background sky, while those closer to you have a more intense value to their colors. They remain sharp because they are closer.

This is a fantastic technique to give your work the needed depth of focus.

In this example, I'm using only blacks, whites, and grays—but notice how the darker leaves come forward and the faded ones disappear into the background.

## Focal points on the panel

Color can lead your viewer to the areas of the panel or page you want them to focus on, and good colorists understand this. Having a brighter color in the middle of the panel draws the eye to that point, helping to ensure important plot elements are seen by your readers.

## Monochrome coloring

This is sometimes used to set a mood. This limited color technique can be quite effective too.

## Expressionistic coloring

The sky is blue—sometimes. And sometimes a person's face is purple, or red, or yellow, or green, to convey a sense of drama and dramatic lighting. Film uses colored filters to achieve this effect, and the graphic novelist can do the same thing by experimenting with color choices.

# Chapter 7
# Creating worlds

CREATING YOUR WORLD CAN BE LOTS OF FUN. FOR THE ACTION AND CHARACTERS TO WORK IN YOUR STORY, YOU NEED TO IMAGINE THE WORLD THEY LIVE IN JUST AS CLEARLY AS YOU NEED TO IMAGINE THEM

# CHARACTER ENVIRONMENTS

**W**hatever the world your characters inhabit, it needs to be realistic and carefully thought out if you're going to convince readers that it's worthy of their attention.

Whether your story takes place in the real world or some far-off planet, making it seem real is key to ensuring your story works.

For the most part you should follow whatever style you've established in creating your backgrounds and environments. An exception to this is often found in Manga works of Japanese artists, who often have ultra-realistic backgrounds no matter how cartoony or abstract the character designs are.

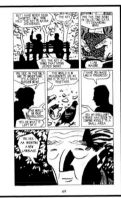

Whatever your decision, you need to make sure it's convincing to the reader in order to grab them fully.

In David Mazzuchelli's adaption of Paul Auster's *City of Glass* he created a dark and somber world done in a combination of realism and abstract simplified cartoon—with tremendous success.

Mazzuchelli's master use of shadow evokes a sense of foreboding throughout the story.

# Perspective

Have you ever stood at the end of a road and noticed that it looks like the two sides connect at the horizon? Or at the far wall of a dungeon room? That's perspective.

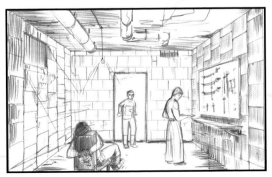

Perspective is a mathematical system of rendering three-dimensional objects on a two-dimensional (your paper) surface. Let's look at some useful examples.

Figure 7.1

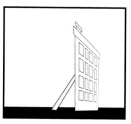

Does Fig. 7.1 contain a block or just a square? You can't tell. If you stand and look at a building straight on it looks flat.

We know it's not flat, yet suppose this building is actually just a set like on those old movie westerns?

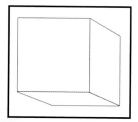

Figure 7.2

To solve this dilemma we use perspective when drawing three-dimensional (3D) objects. Let's look at that block again from a different angle.

See how we can see the side and the bottom now. Not only do we know that this is not just a square, but it's a block—and what's more, it's floating in space above us.

This is because we used one-point perspective. Here's how we did it.

**Tools you will need**

**1.** Paper
**2.** Pencil
**3.** Ruler (or a T-square and triangle if you want to be very accurate)

## One-point perspective

One-point perspective rule: All vertical lines remain straight up and down; all horizontal lines facing you remain straight. Horizontal lines facing away from you go to the vanishing point (VP).

**Step 1:** Start with a horizon line—a straight line that goes across your page. A horizon line is the eye line of your reader. If you were to stand outside in a wide open area you would be able to see into the distance (or the horizon).

horizon line

**Step 2:** Then set a vanishing point on your horizon line. Note that it's important you use an X to mark your vanishing point because that point needs to stay precise—and the point at which the two lines creating the X intersect will stay precise, unlike a dot which can accidently grow as you work your drawing.

horizon line                    VP
                                 ✗

horizon line                    VP
                                 ✗

**Step 3:** Take your pencil and draw your square. Since this is one-point perspective one side of the block will remain flat.

Try to draw your square as perfectly as possible—use your ruler.

**Step 4:** Take your ruler and draw a light line from the top corner of your square back to your vanishing point.

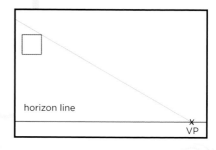

**Step 5:** Then do the same thing from the bottom corner of your square back to the vanishing point.

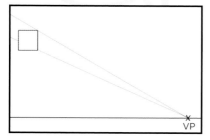

**Step 6:** Close off the back of your block—try to make it look about the same size as the front. This vertical line should be straight up and down like the other edges of the block.

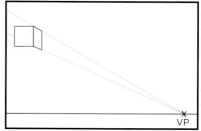

**Step 7:** Take a pencil and draw a line from the bottom left corner of your block back to the vanishing point.

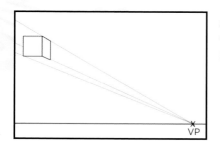

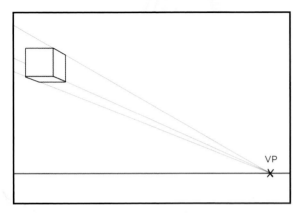

**Step 8:** All that's left is to close off the bottom line of your block—and that horizon line goes straight across and closes the block.

I know what you're saying—"But my story doesn't have a lot of floating blocks in it." No problem.

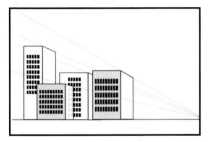

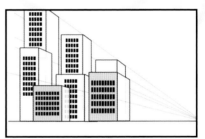

**Step 9:** By repeating the steps above, you can create a cityscape made out of blocks.

**Step 10:** You can even stack the blocks on top of each other to build up skyscrapers.

## TIPS

**1.** Make sure you use a sharp pencil.

**2.** If you have a lot of lines to draw, it's a good idea to draw all the lines going to the vanishing point with a light colored pencil—like red or blue.

**3.** Use a metal ruler—wooden rulers sometimes go bumpy with age.

## Two-point perspective

If one-point perspective is cool, two point is awesome.

| | |
|---|---|
| horizon line | horizon line |

**Step 1:** Start with your horizon line—same as you did with one-point perspective (see page 111).

**Step 2:** Instead of putting one vanishing point in the middle of the line—as you did with one-point perspective—place one to the left (VP1) and one to the right (VP2).

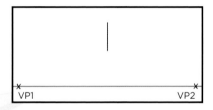

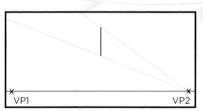

**Step 3:** Let's do the block again—this time you draw only the vertical edge straight up and down.

**Step 4:** Take your ruler and draw a light line from VP2 to the top of your vertical block edge. Then draw another line from VP2 to the bottom of your vertical block edge.

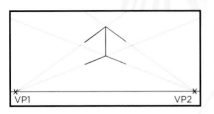

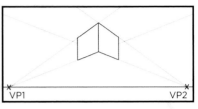

**Step 5:** Then draw the lines from VP1 and VP2 to the top and bottom corners of the block.

**Step 6:** Close the block on both ends with straight vertical lines.

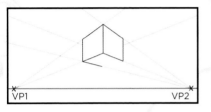

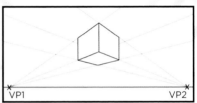

**Step 7:** The bottom is actually easy—you want the sides of the block to follow parallel lines, so the far bottom left corner goes over to VP2.

**Step 8:** The far right corner goes over to VP1.

You now have a block in three dimension.

**Step 9:** Going from this floating block to a city follows the same process you did for one-point perspective, adding blocks on top of blocks to build up your city.

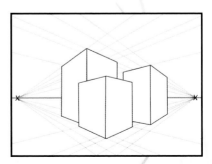

## OVER TO YOU

Try practicing this technique by drawing the room you're in right now.

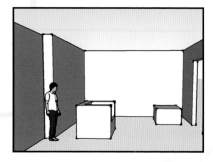

Let's look at examples of perspective in the real world.

Real-world examples of two-point perspective.

## Three-point perspective

Let's not spend too much time on this one, because it's getting complex, but it involves introducing a third vanishing point (VP3) into your image.

**Step 1:** If we raise the horizon line, the image will look like it's viewed from above—like a bird's eye view.

**Step 2:** While lowering the horizon line gives a view from below—as if you're standing amidst a bunch of tall buildings. This is effective if you're trying to demonstrate your character's first time in a big city.

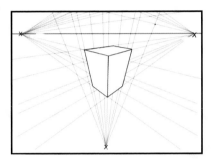

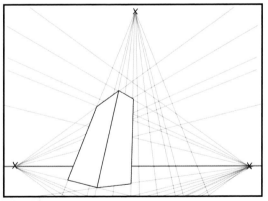

Effective perspective will do wonders for the world you create.

# Using shapes to create organic objects

Remember when you were a kid and you drew lollipop trees? Well, you weren't too far off. Let's go through a method of drawing trees that uses this base to start with.

**Step 1:** Start with your lollitree.

**Step 2:** Add a few more circles to the leafy area.

**Step 3:** Loosen up the "stick" part of your tree.

**Step 4:** Draw in a few branches off that "stick."

**Step 5:** Go over your lines to make the tree.

**Step 6:** Now add some texture to the leaf area.

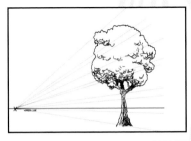

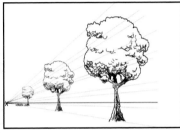

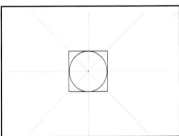

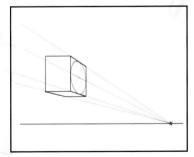

## To add trees in perspective

**Step 1:** Place your first tree closest to your reader. From the top and bottom of the tree draw lines back to the vanishing point.

**Step 2:** Drop in your second and third trees within this set of lines.

## Creating round shapes in perspective

**Step 1:** Start with a square.

**Step 2:** Draw an X going from all four points.

**Step 3:** Draw a horizontal center line that intersects with the center of the X.

**Step 4:** Draw a vertical center line that intersects with the center of the X.

**Step 5:** Now that you've split the square into pie pieces it's easy to follow the edges and draw a circle inside the square.

**Step 6:** Then repeat the same process—but this time using a block in one-point perspective.

**Step 7:** Draw your block.

**Step 8:** Draw an X going from all four points on the side of the block that goes to the vanishing point.

**Step 9:** Draw a horizontal center line that intersects with the center of the X, making certain the line goes to the vanishing point.

**Step 10:** Draw a vertical center line that intersects with the center of the X and drop the circle in place. Now you have a circle in perspective.

# Chapter 8

# Character designs: in depth

NOW YOU'RE FAMILIAR WITH THE BASICS, LET'S TAKE A CLOSER LOOK AT DEVELOPING YOUR CHARACTERS WITH A FEW PROJECTS FOR YOU TO TRY

# CREATING INTERESTING CHARACTERS

**C**rucial to any story, developed, interesting, and believable characters distinguish a successful graphic novel from the rest, and make or break your story.

Back in Chapter 2 we discussed various ways to create interesting characters. Let's look a little bit deeper and come up with some ideas.

As we develop our "cast" we want to make certain they each have a unique look and feel to them. Varying the look of your character is important to keep things interesting. Here are some examples of interesting character design.

This first one is for an upcoming *Space Pirates* graphic novel. The design is clean and simple but the character looks as if he could be real. Note the crooked head scarf and the wrapped boots. Like Captain Courageous, this warm-hearted lunk has a soft spot for kids.

This second design is a non-human type of character, but he's got human characteristics. Looking at him you get the sense that he's pretty mellow, both by his expression and the way he stands.

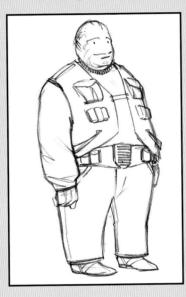

There are a lot of ways to get into character model sheets. Look at fashion shoots for the way people move or stand, and for the way accessories add to a character's look.

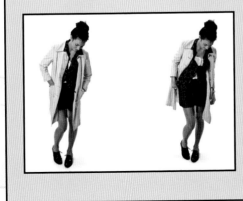

## Creature features

Even if your character isn't going to be human, you still want to design the shapes to make up the character the same way we did back in Chapter 2.

Let's look at these two loose head designs. The one on the left is the basic line for a human character—with divisions for eyes, nose, mouth, and ears. The one on the right uses the same basic components but with a change in proportions.

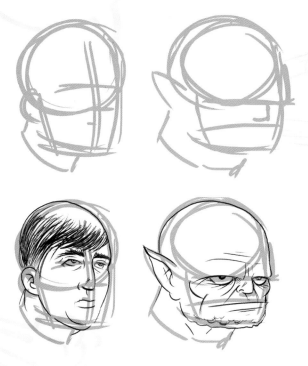

So when the details are put in, you end up with a fairly normal-looking man and a more alien-type being.

**OVER TO YOU**
Create a sidekick or partner.

## Tools you will need

**1.** The model sheet you made in Chapter 2 (if you skipped this step then go back and complete it now)
**2.** Pencil
**3.** Pen and brush
**4.** Ink
**5.** Razor
**6.** Sheet of heavy bristol any size

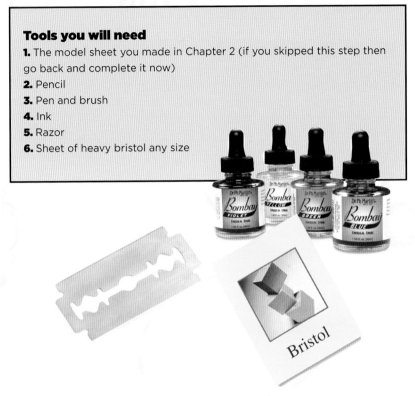

Look at your model sheet. You created this character using a random draw of personality traits, backgrounds, and details. It's time to put your creative brain into high gear.

When creating a sidekick or partner for this character, why not adopt the Mutt and Jeff route—whatever physical traits you gave the first character go in the other direction with this one.

You might have to give it two or three tries, tweaking the characters just a little bit as you go. There are an endless number of varieties you can come up with—play with the designs until you come up with something that suits your project.

## Keeping it real

You need to make your characters real. They need to fit the style of your graphic novel and they should look like they've lived.

**TIP** Keep a sketchbook on you. It doesn't have to be a big one—it can be pocket sized—and use it to sketch people you see who are interesting.

# Stereotypes

These are often used in comics because the author has only a limited space to tell a story, but your story can benefit by going against the grain. In Arthur Adams' *Monkey Man & O'Brien*—which he based on his favorite childhood movie (the 1933 *King Kong*)—he made the giant gorilla the brain and the pretty blonde the brawn.

Batman is a great example of a character who doesn't "fit" the expected look—with his dark somber colors and his devil-horn-like ears he looks more like a villain than he does a hero—but he's become one of the most popular superheroes in the history of the genre.

Japanese Samurai armor from the sixteenth century like this was used as the model for Darth Vader in *Star Wars*.

Designing your characters is a lot like casting a movie—and as a lot of movie directors will tell you, if you cast your characters correctly the movie virtually makes itself.

Close your eyes—well, read this first and then close your eyes. Picture a seasoned police detective in a city overrun by crime. He's a tough cop but he's trying to play by the rules.

Did you picture a big burly cop? How about picking an actor?
Stallone? Eastwood?

Director Christopher Nolan decided to pick Gary Oldman to play police lieutenant James Gordon in his *Batman* films for Warner Bros—unconventional casting but it works because Oldman showed he had the attributes to play the role.

There was equal controversy when director Tim Burton cast actor Michael Keaton as Batman in his 1989 film—fans objected because Keaton didn't "fit" what they envisioned Batman to look like, but Keaton and Burton proved them wrong and the movie became a blockbuster hit.

***TIP*** Use reference for inspiration to base your characters on. The makers of *Star Wars* looked at a lot of different historical reference including Japanese Samurai armor (especially for the Storm Troopers and Darth Vader).

## OVER TO YOU

Now you're going to create a batch of characters here. Let's start with just head shots. In column A I want you to draw your first thought—go right down the line, no extra thought; just what comes to you initially. Then go back to column B and push the idea to come up with a different take on the character. If you don't want to draw in your book, use a separate sheet of paper.

Example: Veteran police commissioner:
**A.** A big burly tough guy.
**B.** A middle-aged woman with a strong jaw.

See how it works?
Draw the following characters in the A column first—don't give it a lot of thought—just draw what comes out of your head—first impressions only.

Country doctor

Judge

Scientist

Explorer/Adventurer

Spaceman

Artist

Beatnik

Monster

Alien

Mad scientist

Now go back to the top and start in column B. Give each of these some thought. What is the stereotype? What is expected? What is required?

Come back here when you've finished. Good luck.

All right? Finished? Take a look at the results.
Criteria for judging your sketches:
**1.** Is the character interesting looking and not too generic?
**2.** Does the character look "real"?
**3.** Does the character meet the bare minimum requirements for your reader to understand who they are?

Sometimes you nail the design in the first try—at other times it takes further thought. There is probably good and bad in both of your columns.

| A | B |
|---|---|
|   |   |

## Keeping it real references

Many graphic novel authors cast their characters using real actors as a base. In my own *Dracula* book I'm using 1930s actress Carole Lombard as a loose base for the Lucy Westenra character.

Actress Carole Lombard                    Lucy Westenra by Andy Fish

Here's an important exercise for you: many new graphic novelists don't like to use reference because it's extra work—but it pays off in spades.

## OVER TO YOU

Draw the following objects without looking at a reference. These are items you probably see everyday, but how closely do you look at them? We'll find out.

A telephone
A dog
A garbage truck
A traffic light
A hamburger (or your favorite hand food if you don't eat burgers)
A few other things not on this list, that you see every day

When you've finished, come back here. Remember no peeking—no reference.

**REFERENCE**

Now let's see the difference when we actually have references. Compare the items on this page with what you drew—how close were you?

**OVER TO YOU**

Now go and pull some additional references for some other random items: a dog, a horse, a car, a street lamp. References can be found in many places: the library; the Internet (Google images or Bing work great); magazines and newspapers (some artists keep a "clip file" of items they might want to draw later); even phone books (in the old days if we had to draw a tractor, we'd go to the phone book to look at the ads in the back).

# Finished?

Good, let's look at the results. You should see some big differences. The first list without reference will probably be a bit on the generic side, while using reference will improve your work dramatically.

Things you see every day—such as a traffic light—have little details that you don't always notice, while the hamburger (or favorite food) probably looks pretty accurate even without reference because you actually look at your food when you eat it. Even if you don't realize it, you tend to study the food you eat but look only casually at other everyday objects like phones and traffic lights.

# Chapter 9

# Motion, emotion & energy

CREATING MOVEMENT WILL
MAKE YOUR STORY EASIER
TO FOLLOW AND ADD AN
ELEMENT OF REALISM
AND BELIEVABILITY TO
YOUR CHARACTERS AND
THEIR ACTIONS

# BODY MODELS

**C**reating dynamic action poses is important to your storytelling. You have to be both movie director and still photographer as you try to pick which of your action shots to use.

Let's look at those body models we looked at in Chapter 2.

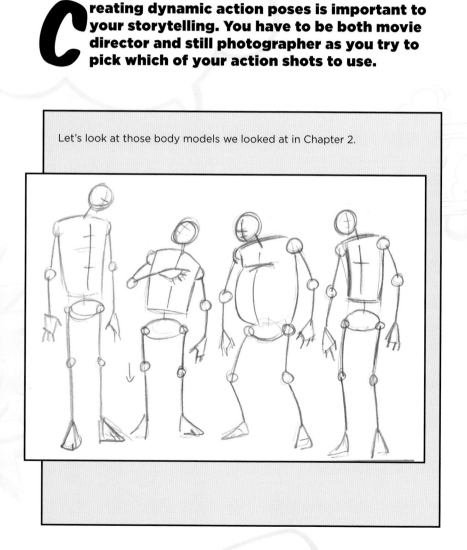

Now let's take these figures and use what we learned with the lesson on foreshortening (see page 65) to make some dynamic poses.

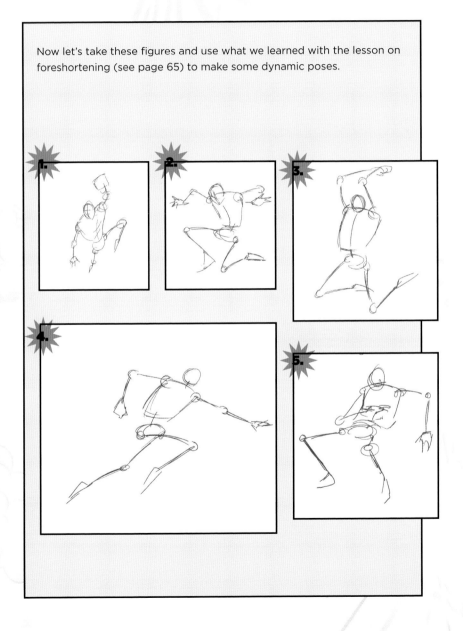

# Storytelling

Here's the setup—this is from my graphic novel *Dracula: Children of the Night*. In this scene, Jon Harker is running terrified in the haunted woods of Transylvania—being chased by who knows what.

Figure 9.1

Figure 9.2

Figure 9.3

**Step 1:** I started this full-page shot by loosely sketching in the haunted woods.

**Step 2:** Then I made a loose figure sketch of Harker as he runs through the woods. He's running in typical comic book hero form, meaning he's leaning over so far that in reality he would fall and smash his head open, so I gave the figure another try.

**Step 3:** For the next version I tried him swinging on a rope because I had a similar shot in the story where he ties his bedsheets together and makes a rope to escape his room. I thought this might add balance, but the result looked stupid and was too "Spidermanish."

**TIP** Sometimes I'll try five or six different poses before I choose the final one while I work out the best ideas for creating an exciting bit of storytelling.

Figure 9.4

**Step 5:** Finally, I gave it a bit more energy by tilting the background a few degrees and adding a bright splash of color to his vest to make his figure pop off the page.

**Step 4:** The fourth attempt was more straightforward, but since Harker is an ordinary guy I felt his method of running— even in a terrified state—would be very normal looking. This worked for the story but it's just a bit too generic to succeed.

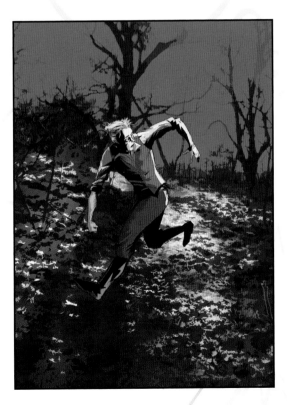

## Expressions and emotions

If you don't use the right expressions, your characters will feel like action figures jumping into play with no clue as to how they feel, which will weaken your story. Take a look at this guy—Captain Steroids. He's ready for action but he looks too stiff. He looks like he just came off the shelf at your local toy store.

Look at how much better this is if you get into the character's head and you see what he is feeling. I wouldn't mess with this guy.

To understand expressions you must first look at the emotions they are based on. Robert Plutchik developed an interesting theory of human emotions, and—much like the color wheel (see page 94)—he developed a wheel of emotions (Fig. 9.6).

Figure 9.6

Plutchik broke down emotions into eight basic categories.

| BASIC EMOTION | WHICH IS THE OPPOSITE OF |
|---|---|
| Joy | Sadness |
| Trust | Disgust |
| Fear | Anger |
| Surprise | Anticipation |
| Sadness | Joy |
| Disgust | Trust |
| Anger | Fear |
| Anticipation | Surprise |

The possible combinations are endless—especially when you consider that each emotion has degrees:

Sadness> depression> dismay> agony> suffering> anguish

Anger> frustration> envy> exasperation> rage> fury

Expressions are a form of shorthand too. Here are some standard expressions:

Anger

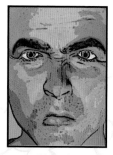

Disgust

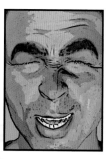

Joy

Anticipation

Surprise

Sadness

Trust

Fear

If you combine two emotions, those expressions get even more complex:

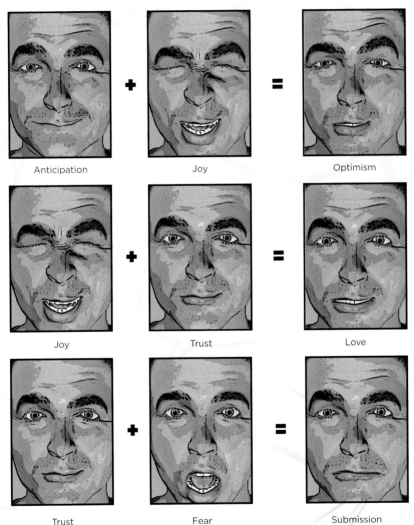

Anticipation + Joy = Optimism

Joy + Trust = Love

Trust + Fear = Submission

## Three-quarter views

Showing a character's head in a slightly turned view—usually called a three-quarter view—is a more exciting shot than just showing it straight on. It's also more useful because most of the time the characters in your graphic novel are not going to be facing front all the time.

**Step 1:** Draw a circle—as you did in the how-to-draw-heads lesson (see page 25).

**Step 2:** Draw a jawline.

**Step 3:** Draw a center line as if you were drawing a line down an egg and then turning it slightly.

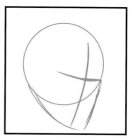

**Step 4:** At the halfway point, draw a vertical line which will be where the eyes will go.

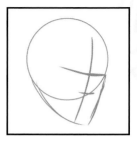

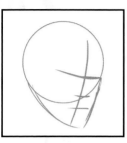

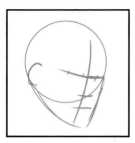

**Step 5:** Halfway from the eye line to the jaw line is where the nose is—so draw a small line right about there.

**Step 6:** Halfway from the nose line to the jaw line is where the mouth is—so draw a line there to hold the space for the mouth.

**Step 7:** Now the dimensions are done, draw in bumps for the ears and make four evenly spaced marks on the eye line—these will be where the eyes go.

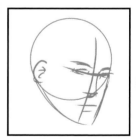

**Step 8:** Draw in the lines for the eyes, the nose, and work up the eyebrows and the ears.

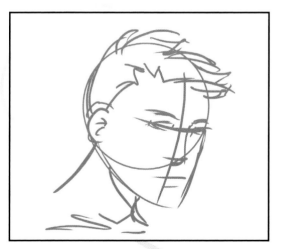

**Step 9:** Work in the hair using shapes, and polish up the details. You've got the basic lines for a pretty good three-quarter view which you'll need soon enough.

## OVER TO YOU

Here's a sheet of head shapes. Sometimes the best way to draw an emotion is to do it quickly, so without giving it much thought just jump in and try to finish this with the first thing you think of when you read each emotion.

 **+**  **=**

Fear                    Surprise                    Awe

 **+**  **=**

Surprise                    Sadness                    Disappointment

 **+**  **=**

Sadness                    Anger                    Remorse

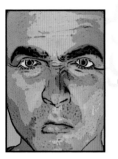

Anger

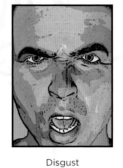

Disgust

Contempt

Combine the expression with the action pose and you will have an awesome figure coming right at the reader.

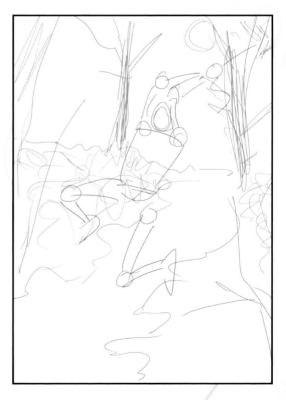

## Body language

Body language has a lot to do with a successful drawing, too. Body language is like expressions for your body and is a huge component in effectively telling your story. You are the movie director here, your graphic novel characters are your actors, and it's up to you to make sure they perform.

### Look at this example

Here's the setup (Fig. 9.7). We come in at the middle of a scene in which two characters are talking about going somewhere. You are one of them since the scene's told with your point of view. See how that worked? Without the pictures we could have told the same story. You didn't really need the pictures at all. Why even bother with this whole graphic novel thing—why not just write a book? How about this one:

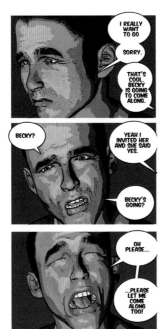

Figure 9.7

### Wow

Same dialogue as Fig. 9.7. Same exact dialogue—but by changing the body language of the character (Fig. 9.8) I've altered the delivery of the dialogue.

We started the story with the same panel—it's clear the character isn't interested in going wherever you're asking them to go (and why wouldn't they want to go with a charming person like you?). But it's panel 2 that takes the story somewhere else.

In Fig. 9.7, panel 2, it's clear that the character is excited. Becky is someone he likes. Now he wants to go, and that's emphasized with panel 3.

Now he's changed his tune—he's begging to go.

But Fig. 9.8 takes us in a different direction.

Fig. 9.8, panel 2: can you hear the contempt in his voice? He really doesn't like Becky—and that's emphasized by the look of disgust on his face.

Even though we read it differently, exactly the same exact words are used in both examples.

By combining the words with effective pictures we have changed the way the reader comprehends and "hears" the delivery of those words.

You can almost hear the sarcasm in his voice in the final panel (Fig. 9.8).

Amazing, isn't it?

Figure 9.8

It works with expressions as well. Let's look back at our expression sheet (see page 142) and add a simple piece of dialogue. As with all the pictures, "listen" to how each one reads differently.

Which one is the most sincere? The least? Which one seems the most desperate? By adding the expression to the delivery of the dialogue you are essentially getting a better "performance" out of your characters.

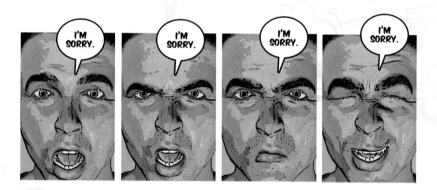

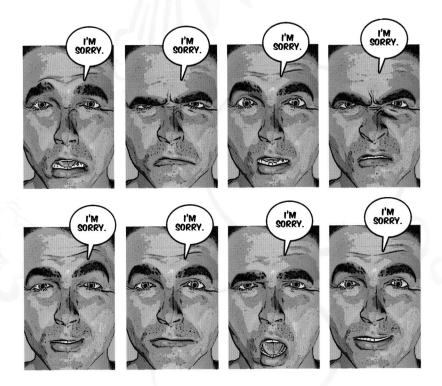

## OVER TO YOU

Experiment with different expressions combined with lines of dialogue. See
how you can create these varying degrees of "delivery" from your actors:

Sincerity
Depression
Sarcasm
Wit
Anger

# Chapter 10

# Stories

GRAPHIC NOVELISTS WORK IN A VARIETY OF SCRIPT STYLES—WHETHER YOU'RE ADAPTING A WELL-KNOWN BOOK OR NOVEL (MAKE SURE IT'S IN THE PUBLIC DOMAIN OR GET PERMISSION) OR AN ORIGINAL CONCEPT, YOU'LL NEED SOME KIND OF SCRIPT TO GUIDE YOU

# SCRIPTING

**T**here are two methods for scripting with graphic novels—the plot method and full script. Both are very different and can produce equally different results. The method you choose to work in is completely up to you.

## The plot method

This was first developed by Stan Lee when he was writing eight Marvel Comics titles a month in the 1960s. Stan couldn't possibly produce eight full scripts to keep his artists busy so he simply came up with a plot written of anything from one to five paragraphs that he would give to his artists. They would then take the plot and draw it in pencil as a 22-page story. When they were finished they would bring the pages back to Stan and he would write in the dialogue based on what they had drawn.

Working in a plot style, the film *Star Wars* might read like this:

In a far-off galaxy, a young farmboy named Luke Skywalker dreams of joining his friends in the rebel alliance. Their sole mission is to defeat the evil galactic empire led by Governor Tarkin, who has developed the ultimate weapon—a planet-destroying battleship called the "Death Star."

Objecting to Luke "following in his father's footsteps," his aunt and uncle, with whom he lives, refuse to allow Luke to follow this dream.

Half a galaxy away, rebel leader Princess Leia hides a desperate secret message in a robot and launches it to the home planet of former Jedi master Obi Wan Kenobi—coincidentally the same planet that Luke is on. Through an ironic twist of fate, Luke's aunt and uncle are killed by the empire's troops when it's discovered this robot has come into their possession. Luke finds Obi Wan, and the two of them go off to join the rebel cause.

## Freeing up the storyline

A plot makes up most basic aspects of the story. Note in the plot above, there is no mention of Darth Vader, or Luke's training as a Jedi—or Han Solo—those are all sub-elements of the overall plot. So working in this plot style the artist is given a lot of freedom to develop the storyline.

Now I hear what you're saying—"But what if I'm writing and drawing this graphic novel? How would the plot method help me?"

Well, if you're like me, you're anxious to get to the drawing board, so adopting the plot method will allow you to jump into the story faster.

## Advantages of the plot method

Allows more creative freedom to the artist. In the case of the single creator, it allows a more fluid telling of the story because you aren't getting bogged down in details (yet).

## Drawbacks of the plot method

Can allow too much freedom to the artist, and the writer can lose control of the story if the artist goes off on a tangent. In the single-creator situation it can cause you to forget details that you wanted to get into your story.

# The full script method

This is just like it sounds. Everything is in there—just like a movie script. So if we were telling the *Star Wars* story in full script it'd have everything already figured out and the artist would just draw what is written.

## Page one: three panels, all the same size

### Page one, panel one

A small space craft is hurtling through space—explosions all around it—something is chasing it. The small craft is heading away from us into the distance.

NARR: A long time ago in a galaxy far far away...

SFX: Bchow. Bchow.

### Page one, panel two

Same shot but the small craft is smaller still as it pulls away, but now we see the ship that's chasing it—and it's huge.

REBEL CAPTAIN: They're gaining on us.

SFX: Bchow. Bchow.

### Page one, panel three

Flip around so the small ship is now closest to us, and the huge imperial cruiser is right behind it. A rocket has struck the ship and it's come to a dead stop. The crippled ship is smoking.

REBEL CAPTAIN: We're hit. They've got us.

SFX: Bchow. Kaboom.

So you can see the difference—the script above is for page one of a story that is probably ninety-six pages.

## Advantages of working full script

The main advantage of working full script is that the writer has complete control over the story and the images. The artist is usually allowed to offer suggestions, but for the most part the artist can't make changes without permission.

For the self-creator, working full script allows them to work the bugs out before they get started. For some creators this is the best way to work and this pre-production stage provides stability and helps them make sure they don't miss anything they want to cover.

## Drawbacks of working full script

It eliminates the creative partnership between artist and writer in some cases. It puts a lot of responsibility on the writer. For self-creators, it can take a lot of time to write a full script.

## OVER TO YOU

This exercise will give you a chance to work both from a plot and a script.

**It's really important that you don't read ahead here so that you get no clues as to what we're going to try and do.**

Try to "flesh out" and sketch the first page of the following plot:
"A sheriff confronts a wanted outlaw, and the two square off for a showdown."

 Keep in mind that although this is a plot that would normally consist of several paragraphs, we're only looking at producing a single page.

### You will need
**1.** Reference material; Old West town, cowboys
**2.** Design for the sheriff
**3.** Design for the outlaw
**4.** Figure out some dialogue to move the story along. Do this after you draw the pencil pages.

Let's review. What struggles did you face? Did you know what to draw? Did you struggle with the script? What angles did you choose? Were you able to get everything onto one page?

Now let's move on to the script version.

### Page one, panel one
Old West town, daytime. A dusty old one-horse town.

### Page one, panel two
Sheriff Winston steps out of his office, confronting the outlaw, Barry Ween. Ween is a wanted killer with no remorse.

### Page one, panel three
Closeup on Sheriff
Sheriff: Far enough Ween. This is my town, and there's no room for you here.

### Page one, panel four
Closeup on Ween.
Ween: That's your opinion, Sheriff. I never shot no one what weren't deserved it.

Now try giving the script version a go.

When I'm approaching a script I follow some pretty simple steps:

**1.** Read the script
**2.** Read the script again—this time taking notes and making doodles showing the shots it's asking for.
**3.** Thumbnail

Here's what we have:

### Page one, panel one

Old West town, daytime.
A dusty old one-horse town.

### Page one, panel two

Sheriff Winston steps out of his office, confronting the outlaw Barry Ween. Ween is a wanted killer with no remorse.

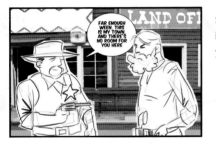

Sheriff: Far enough Ween. This is my town, and there's no room for you here.

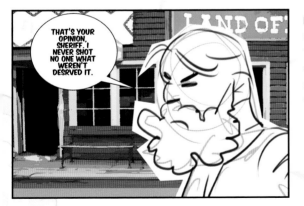

### Page one, panel three

Closeup on Ween.
Ween: That's your opinion, Sheriff. I never shot no one what weren't deserved it.

Figure 10.1

**Page one, panel four**

Close-up on the Sheriff—it's getting intense.

Putting the page together, it looks like this.

Let's look at the results.

The first panel is our establishing shot: it clues the reader into the fact that this is an old West town. Establishing shots generally come at the beginning of a new scene, but they can also be included at the end if you're trying to surprise the reader.

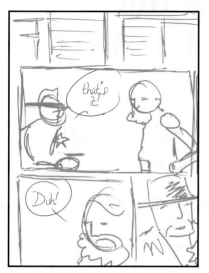

Figure 10.2

While this page (Fig. 10.1) is perfectly acceptable, it's pretty generic when you look at the camera angles and the page layout used. So I'd take this page back to the drawing board and try to mix it up a little bit more.

I broke the page up into a more modern (and hopefully interesting) page layout (Fig. 10.2). The big panel at the top is my establishing shot. Then a panel overlap introduces my two characters followed by close-ups of both the outlaw and the sheriff, which adds to the tension.

Sometimes when I have a script to interpret I might do 2–3 takes on the same panel and try to add some variety to the work.

I take this thumbnail and I work it up with a bit more detail, including a background which I created for my setting.

While I do like this version (Fig. 10.2) much better than my first thumbnail (Fig. 10.1), I want to play with the style a little bit more.

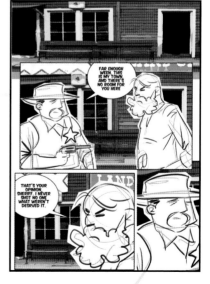

Figure 10.3

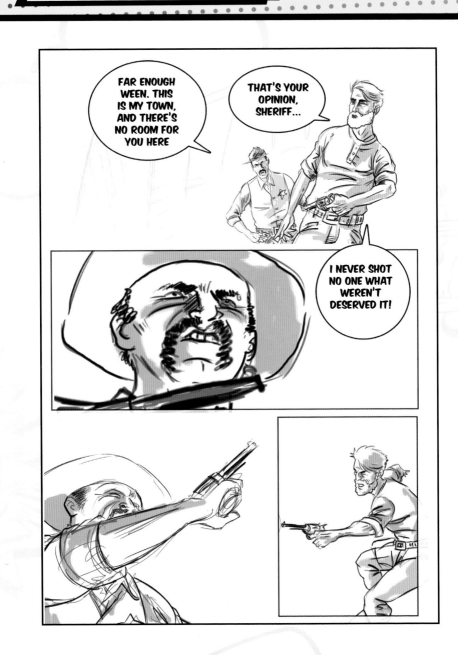

The first page was a bit cartoony so I wanted to try it with a more "realistic" style. I also made some adjustments to the script—which is okay since I wrote it. Normally if you're working from someone else's script it's proper etiquette to talk to them before you add or subtract any story elements. Remember: communication is key.

I took the first two panels: the establishing shot and the meeting of the two characters, and combined them into my new first panel (Fig. 10.3). This allowed me the opportunity to add in a few more action-oriented panels. I also eliminated the outlaw's close-up in favor of a close-up of the sheriff in panel two. Notice that I changed the way the balloons are placed as well so that you get the sheriff's reaction to the outlaw's comment.

The last two panels give some much-needed action on the page. So overall I think this worked pretty well.

# Panel flow

As we've seen in previous chapters, the flow of the panel is important and you need to keep in mind how the reader follows each panel you set up. This is especially critical if you have important objects or dialogue that you want to emphasize in your story—you need to make sure the reader spots them.

In this case, I'd say the guns are important for both characters—and the sheriff's badge is something I want them to see so that it's clear who is the good guy and who is the bad guy in the story.

Sharp-eyed readers will note that I added a bit of depth to the story in the dialogue by having the outlaw declare that he's never killed anyone who didn't deserve it (using his own colorful style of language). As a graphic novel this is important because they should be dealing with stories that have a bit more depth than what might be expected from a regular "comic book."

## Actions & reactions

Legendary film director Sir Alfred Hitchcock once described how editing two different shots together can create a totally unique take on a scene—and the same thing works with graphic novels.

Let's look at this example.

Figure 10.4

Figure 10.5

Employing the same series of shots of the young man but changing the middle panel he interacts with gives a whole different impression of what he's feeling in the final panel—even though the expressions remain the same.

In the first set (Fig. 10.4) you see him spot a lovely young woman, she smiles back at him, and it looks like it's love at first sight for him.

While in the second set (Fig. 10.5) if you substitute a nice-looking hamburger for the young woman you now get the sense that he's thinking about the fact that he hasn't eaten since breakfast.

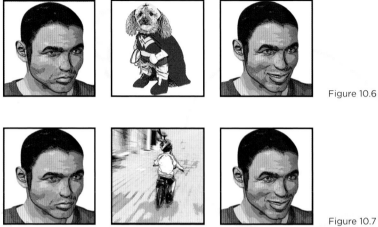

Figure 10.6

Figure 10.7

In the third take on this idea (Fig. 10.6) a dog in a cute little Halloween costume (don't do this to your dog, please) becomes a source of amusement for him.

In the final example (Fig. 10.7) you think that you're looking at a dad watching his son ride his two-wheeler for the first time without training wheels—a moment of pride indeed.

This combination storytelling is simply an example of subject + subject = reaction. The combination of panels arranged in a certain way helps you to tell a story, even without words.

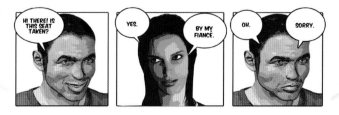

Figure 10.8

# Chapter 11

# Working in digital environments

DIGITAL TECHNOLOGY IS USED EVERY DAY BY MOST GRAPHIC NOVEL ARTISTS. REPEAT TASKS BECOME MUCH EASIER, AND COMPUTERS ALLOW ARTISTS TO STAY IN TOUCH WITH THE REST OF THE GRAPHIC NOVEL INDUSTRY

# TECHNOLOGY

**T**echnology continues to change the way work is done everywhere—and comic books and graphic novels are no exception.

In days of yore, comic scripts were written on manual typewriters and then drawn up on 2x bristol or illustration boards, then handed off to an inker and a letterer who would finish up the art. Next it would be copied and reduced, after which it would be given to a color artist who would assign colors to the story. In the 1940s, the choice of colors was limited, while today (with digital technology) color choices number in the millions.

## Scripts

Today, all scripts are written in word processing programs such as Microsoft Word or Final Draft Pro, allowing ease of distribution to all parties involved as well as the added benefit of tools built into the program—such as spell check, borders and shading, and a whole host of other pieces of technology designed to speed up the writing process.

A writer can now take their plot as a Word document. File, open it, and expand it right in the same program.

# Artwork

Artwork, whether or not it is hand drawn, is eventually scanned into the computer not only for transmission to the publisher and the printer but also to the lettering and color artists. There is just no getting around it: technology is here and it's the forward-thinking graphic novelist who will embrace it and make it work for him or her.

Today's graphic novel artists should at least look at the options and consider using the computer for some part of the production of their work—if for no other reason than to save time.

### Drawing a graphic novel with the computer

I'm going to take you through my process of working digitally by looking at page one of my *Dracula* graphic novel.

## Process

Here's the plot for the first page.

Jon Harker is running through the woods of haunted Transylvania, having just escaped from Dracula's castle. Since I'm using elements of Bram Stoker's original *Dracula* novel, the dialogue in this scene will be Sister Agatha writing to Harker's fiancée, Mina Murray.

We're going to work completely digitally here.

---

**You will need**
**1.** MacBook Pro—but just about any modern computer will do
**2.** Wacom tablet and pen

---

**Step 1:** Before you can do the thumbnail sketch, read the plot through and decide what feel you want this to have. I decided to go for something that will give the feel of a choppy edit.

**Step 2:** In Photoshop, create a new document that is 2 x3 in (5 x 8cm) set at 300dpi. The thumbnails need to be this high level so they can be blown up once you're happy with them.

**Step 3:** Before you forget, name your page. I name my page DRACthumb001.psd. This will make sure I don't accidently lose the file or overwrite another one.

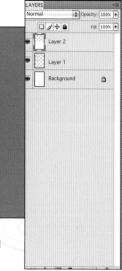

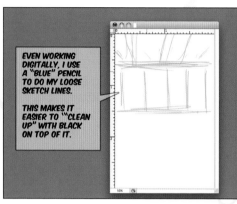

**Step 4:** This is going to be a pretty straightforward page—but that doesn't mean it shouldn't be interesting. I begin sketching in what I think will work using my tablet.

**Step 5:** I decide that I'll establish the spooky woods with the top panel, which will be a wide shot. Then I'll drop in a sequence of four panels as an inset, and I'll finish with a shot of Harker in a clearing in the woods.

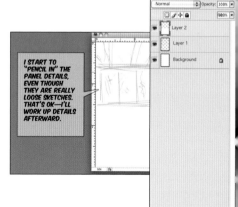

I know it's tough for you to understand my doodles so I've made some notations on the thumbnails to help you decipher them.

Once I'm happy with the thumbnail—although it's rare to get it "right" the first time—the next step is to start sketching in the details.

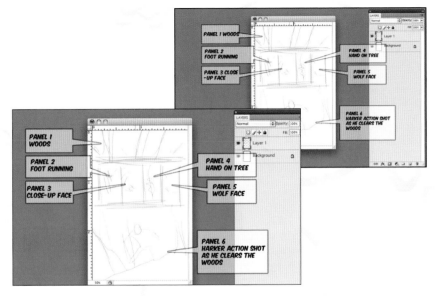

**Step 6:** I resize my thumbnail to 6¼ x 9¼ in (15.5 x 23cm) because that's the size the publisher wants it to be—that's the reason I drew the thumbnail at 300dpi so when I increased the size it would be a simple matter of adding details to the thumbnails.

**Step 7:** I "pencil" in the details for the four-panel sequence—not going into a lot of detail because I'm going for a painting style here. Photoshop has a great variety of paintbrush styles, which means you can build up a painting with layers of color.

**Step 8:** I zoom in and start working up the colors on Harker's face. Using light and shadow and hues that fit a human face, I build up my layers of color.

**Step 9:** I move over to the wolf panel and I indicate the fur on the wolf by using my texture brush. I also color the wolf's eyes red to give him a more sinister, supernatural look.

**Step 10:** For the bottom panel I'm actually going to draw the Harker figure as a separate layer, which will allow me to position him on the background of the woods.

**Step 11:** I begin the background in the final panel. This textured technique is accomplished by "tapping" the pen on the tablet, putting down lights and darks.

**Step 12:** I add in a layer of "mist" and play around with the eraser to make the color less intense and thick.

**Step 13:** Adding colors gives a more finished art page. The color needs tweaking a bit to make sure the figure isn't lost in the background.

**Step 14:** Now it's time to letter the page—and this is where the computer has led the digital way in comics.

**Step 15:** The first thing to do is add a layer and fill it with white paint. Next, bring the opacity down to 70% so that it's like a piece of tracing paper.

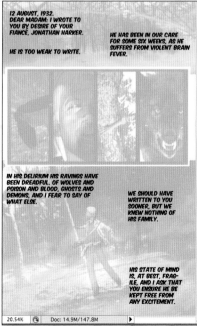

**Step 16:** The next stage is to place each piece of dialogue from the script onto the page in the appropriate areas. The type size is 7, but this is a choice that's up to each creator. Adding the white layer makes the type stand out so it's easier to see.

**Step 17:** To create the balloons, add yet another layer—this one set below all the layers of the type, then go to layer > layer style > stroke.

I set the color of the stroke to black and set the sizing at 6.

I name the layer Balloons.

**Step 18:** Since the words on this page are being spoken by a narrator, use rectangular boxes for them. Turn to your rectangular marquee tool, and draw a rectangle around the first group of text. Make sure you're on the layer named Balloons, and fill it with white paint using the paint bucket.

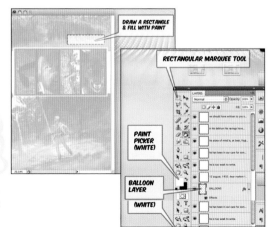

**Step 19:** Go to select > deselect to unselect the box, and then repeat the process on the next group of text. Continue the process until you've made boxes all around your narration, which gives you a fully rendered digital page. (See chapter 12 for more on lettering.)

## Working with a digital tablet

There are a variety of digital tablets available on the market, but the brand I use is Wacom. They've been making tablets since the beginning and in my opinion they are the best. There are a wide range of tablets to choose from. The economical 4 x 6in (10 x 15cm) Bamboo tablet will cost you about US$60 while the top-of-the-line 9 x 12in (23 x 30cm) model will cost about $6,000. The US$60 version is a great choice for a beginner or experienced artist who wants to try their hand at digital art.

Working with a tablet presents a few challenges. First and foremost is the odd adjustment of drawing in one place and having it appear somewhere else. I don't know if there is a correlation, but I've found that people who know how to type without looking at the keyboard seem to have an easier time working with a tablet than those who hunt and peck the keys. Maybe it's a matter of being accustomed to looking at one thing while you work at something else. No matter though—with practice you too can get dazzling results with a digital tablet.

You'll also want to find a comfortable arrangement. Many of these tablets come with a wireless mouse so the tablet takes the place of your mousepad. This isn't for me though, because using the tablet with a mouse does wear down its sensitivity and eventually you'll wear it out quicker.

**Step 1:** Open a new document in Photoshop. Let's make its width 9in (23cm) and its height 6in (15cm) at 300dpi resolution.

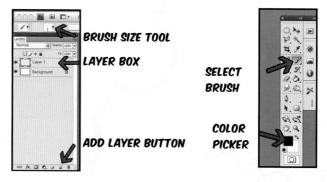

**BRUSH SIZE TOOL**

**LAYER BOX**

**SELECT BRUSH**

**ADD LAYER BUTTON**

**COLOR PICKER**

**Step 2:** In your layer box, add a new layer. Making sure your color picker is set for black, choose a paintbrush set at about 5 pixels.

**Step 3:** Using your tablet, try drawing a series of slanted horizontal lines in your document. Try not to have them touch.

**Step 4:** Add another layer and try doing the same type of lines in the opposite direction.

You've now done some crosshatching with your tablet.

**Step 5:** Save your file as CROSSHATCH.jpg

**Step 6:** To sketch something (or, in this case, someone), open a new document—same as before. Add a new layer. Then set your color at light blue. Use the same size paintbrush as before.

**Step 7:** Loosely sketch in the basic shapes you would draw if you were doing a head-and-shoulders portrait of a person.

**Step 8:** Work in some lines and shapes to make up the face—not too detailed. You'll do that in a minute.

**Step 9:** Add a layer and change your color picker to black. Zoom in so you can start drawing in the facial details

**Step 10:** Keep working those details: eyes, hair. You know what to do.

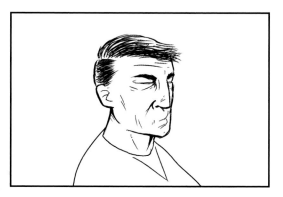

**Step 11:** When you are finished, delete the layer with your light blue lines. You now have a finished portrait produced digitally.

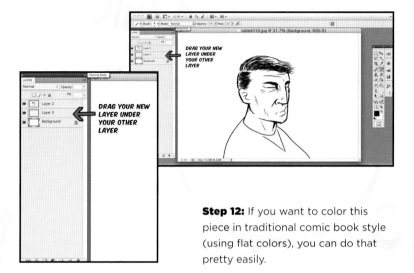

**Step 12:** If you want to color this piece in traditional comic book style (using flat colors), you can do that pretty easily.

**Step 13:** With your portrait still open, add a layer to your drawing and then drag it under the black outline layer.

**Step 14:** Name this layer "Color."

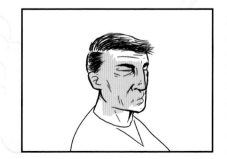

**Step 15:** Choose a flesh color and select a 45pt brush. Working on the color layer (which is underneath the black line layer), begin to paint the color in. The nice thing about this process is that because the black is on a separate layer, you can add the color in and not worry about covering your black lines.

**Step 16:** Go through the same process to choose another color. Pretty soon you have a fully colored image.

**TIP:** Create a cool shadow effect by adding yet another layer over the color layer. Call this one gray, and select gray with your color picker.

**Step 17:** Color in a gray shadow right on top of the colors. Use your eraser to sharpen up the edges.

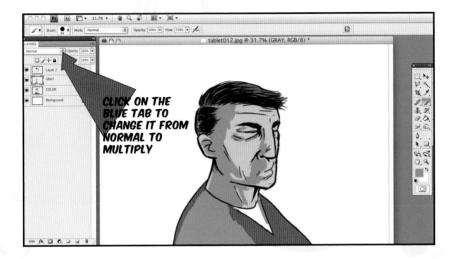

**Step 18:** Go to the layer box and select the gray layer. Then go up to the top and change the layer style from normal to multiply—this gives you a darker shade of color.

# Adding digital backgrounds

Many creators are now using the "cell" method to create their backgrounds. So named because of the technique used in classic animation when an artist would paint a background and then on a separate, clear piece of acetate, they would paint or color the individual figures, allowing them to move the character without changing the background.

**Step 1:** One method of working this way digitally is to select and open a photograph that you've taken yourself. It is important that you always use your own photographs instead of something someone else took—you don't want to violate someone's copyright.

**Step 2:** Keep your portrait open too: you're going to put the two of them together.

In this example I'm using a shot I took in New York City the last time I was there. Your background doesn't have to consist of buildings. It could be wilderness, outer space (good luck taking that picture), or it could be inside your house—it really doesn't matter.

**Step 3:** Click on filter on the top bar of your screen. This will give you filter options. Choose filter > artistic > poster edges to start.

# A CLOSER LOOK AT FILTERS

**L**et's take a closer look at your filter preview window.

Note the following elements of this preview box:

**Image Preview Size**

**A** You can look at it set to 100% so you can see it up close, or you can zoom out to get a look at the overall image.

**B** This image is a preview of what the image will look like if you click over on the far right.

**C** These are your artistic choices: you can try a variety of artistic filter techniques and they will show up in the preview box right away. Your current choice is outlined in a gray box in this example poster edges. Try a few different takes here:

*Poster Edges* gives a "grimy" feel to the image—very urban

*Colored Pencil* mimics a soft pencil drawing

*Cutout* reduces it down to look like cut paper

*Plastic Wrap* is one of the stranger ones, but it can be interesting.

**D** These are your control bars. By sliding these back and forth you'll get a variety of looks.

Within your filter choice, experiment with moving these up and down—and you'll see the results in the preview window.

# FILTER RESULTS

It's amazing the variety of looks you can get using filters:

Palette Knife

Cutout

Film Grain

Plastic Wrap

Fresco

Dry Brush

Watercolor

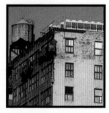

Poster Edges

Colored Pencil

Neon Glow

With the control bars you can get an almost unlimited variety of looks.

**Step 4:** Once you've chosen the filter effect, you can go a bit further and try to mess with the results a little more. Go to images > adjustment > hue/saturation and move the scroll bars around until you get an interesting (and sometimes abstract) color scheme.

**CHOOSE THE MAGIC WAND TOOL**

CLICK INSIDE THE WHITE AREA TO CREATE THE MARCHING ANTS

**Step 5:** On the portrait image you made, go to layer > flatten image, and take your magic wand tool and click it in the white area of the portrait. You'll see a blinking, dotted line—sometimes referred to as "marching ants," which means you've selected all the white areas.

**Step 6:** Go to select > inverse. You'll see the ants now surround the outline of the portrait.

**Step 7:** Choose your move tool (if you hold your mouse over the tool bar you'll see the names of all the tools pop up). Place it right on the inside of the portrait—a little pair of scissors will now appear. This will allow you to move your cutout portrait around—and you can even drag it on top of the background image you made.

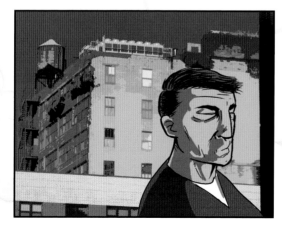

**Step 8:** You can move the portrait image around and place it where you want it in the background. You've now got a pretty cool background behind your amazing digital drawing.

# Chapter 12

# Lettering

THIS CAN BE HAND-RENDERED OR DIGITALLY PRODUCED. IT IS VERY EASY TO DESIGN YOUR OWN FONTS USING A COMPUTER SO WHY NOT PLAY AROUND AND SEE WHAT YOU CAN COME UP WITH YOURSELF?

# DOS AND DON'TS

**L**ettering is often an afterthought when producing your graphic novel—but nothing could be worse for your result. Like color, fonts can be used to create atmosphere. Good lettering is imperative if you want your graphic novel to be readable and professional-looking. Bad lettering will sink your whole project.

More and more creators are relying on the computer to letter their stories, since handlettering can be difficult. If you use a computer to letter it is a lot easier to make changes should you need to.

*TIP*  If you use a computer to letter your comics and graphic novels do not use Comic sans as your font choice—it just looks bad.

## Delivery

Good lettering is essential in helping readers through your story— keeping them interested and getting critical information out. It also is how your characters "deliver" their dialogue, which gives them a good performance over a bad one.

Your characters are like actors and you are the director—how you have them deliver their lines is crucial. Like a good director, you have to motivate your actors—making them deliver the lines in the way you intend is a technique that takes practice and understanding.

Let's take a look at a page in my *Dracula* graphic novel.

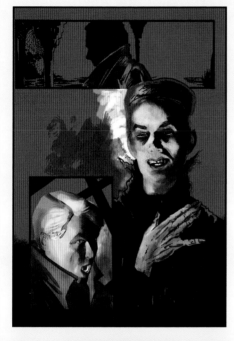

In this page, Jon Harker has arrived at Dracula's castle and has found it deserted when suddenly Dracula appears—surprising him.

The page flows from left to right, top to bottom. Harker is in silhouette in the first panel, but I make sure his jacket is recognizable so you'll get that it's him when he's revealed.

This is an ambitious page layout in which the balloons will play a large part in directing the reader's eye.

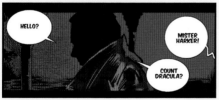

In this first panel I've tried to set a sense of delay between the time Harker first says "Hello?" and the response. It's as if Harker's words echo in the empty castle for a few seconds before Dracula responds.

Trying it in a different way, if you move all the dialogue to the right hand side of the panel, it creates a sense of the scene starting quietly. You get the impression that Harker hesitates before calling out. Notice, too, that the balloons overlap to give the impression of one character speaking over another.

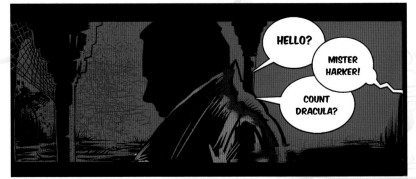

In the bottom two panels of the page there is a rather long monologue by Dracula which is direct from Bram Stoker's novel. In this first example I manage to fit most of it in one big balloon, and while this might be okay, it kind of makes it seem like Dracula just downed a pot of coffee before he gave his line.

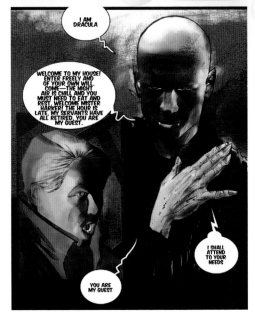

## Alternative delivery

Let's try the sequence another way.

This version breaks the dialogue down into smaller bites—it also "slows down" the delivery of the lines by the character.

Notice the punch added to certain words?  By making some words bold it gives the impression that a character is emphasizing those words as they are said. It's a good trick but you don't want to overuse it.

**TIP** Run the dialogue through your head and try to picture the characters actually saying their lines—that'll help you make the right choices.

Lastly, by having the line "I shall attend to your needs" off to the bottom right, the page has a nice flow, getting your readers to turn the next one.

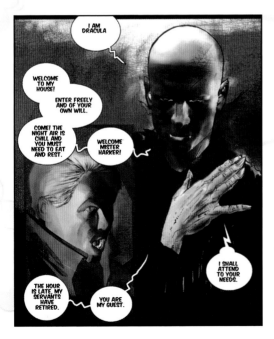

## Sound effects

When you're writing sound effects, it's important that you use a different style to that of your dialogue.

Look at this example:

In Fig. 12.1 it looks like someone is saying "Bang!" because I used the same font as I used earlier for the dialogue.

Figure 12.1

Figure 12.2

It's even more confusing when I try to use it along with some dialogue.

Mixing up the font is a better way to go. Although this choice is an improvement, the font is a bit too generic (I think it's Arial) and mechanical-looking.

Figure 12.3

Figure 12.4

This one is a bit better. I'm slanting the word "Bang!" to make it stand out a little bit more. I also put a stroke around it, to make it pop off the background.

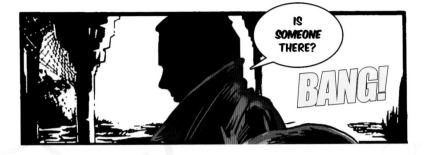

Fig. 12.5 is the best one so far. This font choice is far enough from the dialogue font to make certain it stands out from the words that are being spoken.

Figure 12.5

With Fig. 12.6 I added a layer behind the word "Bang!" and used my elliptical marquee tool to create some big globs behind it.

Figure 12.6

Then I filled the globs with black paint. It created these kind of "Kirby energy dots"* around the sound effect.

Figure 12.7

Fig. 12.8 shows this finished look—and I think this one works.          Figure 12.8

### *Kirby energy dots

Jack Kirby was the king of comics, beginning his career in the 1940s, creating or co-creating such characters as Captain America, The Sandman, and The Boy Commandoes. Kirby hit his stride in the 1960s when he teamed with Stan Lee at Marvel Comics and did an amazing run on *The Fantastic Four* along with virtually every other title Marvel Comics published.

The energy dots were a trick Kirby used to show kinetic energy—for explosions, incredible punches, and anytime he was trying to show an explosive bit of energy.

# The more you know...

## Recommended

### How-to books

*Comics & Sequential Art* by Will Eisner
*DC Comics Guide to Coloring and Lettering Comics* by Mark Chiarello
*DC Comics Guide to Digitally Drawing Comics* by Freddie E. Williams II
*DC Comics Guide to Inking Comics* by Klaus Janson
*Drawing Words & Writing Pictures* by Abel & Madden
*How to Draw Comics The Marvel Way* by Stan Lee & John Buscema
*Making Comics* by Scott McCloud
*Panel Discussions* by Durwin S. Turin
*Understanding Comics* by Scott McCloud

### References

*Comic Artist's Photo Reference: People & Poses* by Buddy Scalera
*Dynamic Anatomy* by Burne Hogarth
*Drawing Dynamic Hands* by Burne Hogarth
*Dynamic Figure Drawing* by Burne Hogarth
*Dynamic Light & Shade* by Burne Hogarth

### Graphic novels

*Asterios Polyp* by David Mazzuchelli
*City of Glass* by David Mazzuchelli
*Goodbye Chunky Rice* by Craig Thompson
*League of Extraordinary Gentlemen* by Alan Moore & Kevin O'Neil
*Pirates of Mars* by JJ Kahrs & Veronica Hebard
*Ronin* by Frank Miller
*The Dark Knight Returns* by Frank Miller
*The Dreamer* by Will Eisner
*Watchmen* by Alan Moore & Dave Gibbons
*Why I Hate Saturn* by Kyle Baker

### Comic strip/comic book collections

*Batman Chronicles V1* by Bob Kane & others
*MARVELS* by Kurt Busiek & Alex Ross

*Superman Chronicles V1* by Jerry Siegel & Joe Schuster
*The Amazing Spider Man Marvel Masterworks V1* by Stan Lee & Steve Ditko
*The Fantastic Four Marvel Masterworks V1* by Stan Lee & Jack Kirby
*The Spirit* by Will Eisner

**Hardware recommendations**
Wacom Graphire Tablet or Bamboo
PC or Mac computer with as much power as you can afford

**Software**
Photoshop 7.0 or higher
Sketchbook Pro
Google Sketchup
Manga Studio by Smith Micro

**Art supplies**
www.cclowell.com
www.dickblick.com
www.comictones.com

**Websites**
www.comicon.com
www.blambot.com—free comic book fonts

**iPhone/iTouch applications**
Comiczeal
Comixology

**Comic book publishers**
Titan Books: UK
DC Comics: New York
Marvel Comics: New York
Dark Horse Comics: Oregon
Image Comics: California

## Graphic novel influences

Graphic novels have taken the publishing world by storm. They are the fastest growing section in libraries and are rapidly generating their own sections in major bookstore chains. Gone are the days when graphic novels would be grouped in the humor section next to Dilbert collections.

It's not a new concept for film makers to look to comic books for subjects—as far back as 1941, Republic Pictures adapted the popular *Captain Marvel* comic book into a 12 chapter movie serial starring Tom Tyler.

In 1943, *The Bat-Man* was released by Columbia Pictures, only four short years after the character was first created. The 15 chapter movie serial was pretty faithful to the comics and starred former Broadway actor Lewis Wilson (whose son now produces the James Bond films) as Batman and fourteen-year-old Douglas Croft as Robin—the only time the Boy Wonder has been played by an actor at the age the character is supposed to be.

While not a complete list, some of the movies made in the past few years based on comics, comic characters, or graphic novels, include:

*Flash Gordon* (1936, 1938, 1940, 1980)
*Dick Tracy* (1937, 1938, 1941, 1945, 1990)
*The Phantom* (1943, 1996)
*Barbarella* (1968)
*Popeye* (1980)
*Heavy Metal* (1981)
*Swamp Thing* (1982)
*Howard the Duck* (1986)
*Teenage Mutant Ninja Turtles* (1990)
*The Rocketeer* (1991)
*The Crow* (1994) and sequels
*The Mask* (1994)
*Ghost in the Shell* (1995)
*Judge Dredd* (1995)
*Barbwire* (1996)
*Men in Black* (1997) and sequel
*Spawn* (1997)
*Blade* (1998) and sequels
*Mystery Men* (1999)
*G-Men from Hell* (2000)
*X-Men* (2000) and sequels
*From Hell* (2001)
*Road to Perdition* (2002)
*Spider-Man* (2002) and sequels
*American Splendor* (2003)
*Bulletproof Monk* (2003) based on Manga
*Daredevil* (2003)
*League of Extraordinary Gentlemen* (2003)

Batman and Robin release Linda from the awful fate Daka had planned for her.

"THE DOOM OF THE RISING SUN"
Chapter 15 Once in a lifetime thrills like this!
"BATMAN"
BASED ON THE BATMAN COMIC MAGAZINE FEATURE APPEARING IN DETECTIVE COMICS AND BATMAN MAGAZINES
A COLUMBIA CHAPTER PLAY

Robin (Douglas Croft) and Batman (Lewis Wilson) save Bruce Wayne's girlfriend Linda Page (Shirley Patterson) from being turned

These serials were strictly low-budget and aimed mostly at the Saturday afternoon crowd, but Hollywood eventually started making big-budget movies based on comic books with *Superman The Movie* in 1978 starring Christopher Reeve as the Man of Steel.

212

*Hellboy* (2004) and sequel
*The Punisher* (2004)
*Batman Begins* (2005)
*Constantine* (2005)
*The Fantastic Four* (2005) and sequel
*Man Thing* (2005)
*Sin City* (2005)
*V for Vendetta* (2005)
*Art School Confidential* (2006)
*Superman Returns* (2006)
*30 Days of Night* (2007)
*300* (2007)
*Ghost Rider* (2007)
*The Incredible Hulk* (2008)
*Iron Man* (2008)
*The Spirit* (2008)
*Wanted* (2008)
*Surrogates* (2009)
*Watchmen* (2009)
*Wolverine* (2009)

Others have been adapted to television:
*Batman* (1966)
*The Incredible Hulk* (1970s)
*Spider-Man* (1970s)
*Wonder Woman* (1970s)
*The Spirit* (1987)
*Tales from the Crypt* (1994)

The list continues to grow with an infinite number of new projects in the works. Graphic novels have made their mark on popular culture—and they aren't stopping yet.

## Glossary

**abstract style:** A drawing style used in graphic novels. See page 14.

**anime:** Short for "animation" in Japanese. Outside Japan, used to refer to Japanese animation.

**bent V:** One of several nose shapes used in the graphic novel genre. When light hits the face from above it forms a shadow under the nose, which looks like the letter V. See page 27.

**bird's eye view:** The action of your novel viewed from above. Useful for showing a large area or setting the action of your scene. See page 46.

**blank eyes:** A technique used to demonstrate that a character is acting or pretending. See page 68.

**bristol:** A special double-surfaced heavy weight paper used for technical drawing and illustration. See page 13.

**burstlines:** Similar to speedlines, these are a visual trick used by graphic artists to show an extreme force or action, such as an explosion. See page 64.

**cartoony:** A drawing style used in graphic novels. See page 14.

**color off-registration:** Applying a color slightly off-register so it doesn't line up perfectly with the other colors or black line art. This is a full color technique, used to give the impression of an old-fashioned comic book page where the print registration wasn't always perfectly aligned during printing. See page 45.

**color shadow:** A method of coloring images using darker hues as an extra layer on top of your coloring. Used to give form to your panels. See page 45.

**color wash:** Coloring that uses only the slightest amount of ink, applied with a wet brush. See page 44.

**comic:** A style of drawing used sometimes in graphic novels. See page 14.

**complementary colors:** Opposite colors that intensify each other when used together. See page 94.

**crosshatching:** A clean series of lines crossing over each other—used to create gray tone and give depth and form to your drawings. See page 44.

**dolphin:** A character who likes helping others and is a team player.

**foreshortening:** A term used in perspective drawing to suggest that something appears closer to the viewer than it actually is, because of the angle at which it has been drawn. See page 65.

**graphic:** A visual presentation of something. As a drawing style, this is quite a

broad term, referring to a more realistic and heavy-line version of the cartoon style. See page 14.

**gutter:** The area between your panels. See page 52.

**hana-ji:** A nose bleed given to a character to demonstrate sexual lust in Manga comics. Not as common in Western graphic novel drawing. See page 69.

**heavy line:** A style of drawing used by various graphic novel artists. See page 14.

**hue:** The value of the color of a given object. See page 96.

**intensity:** This refers to the amount of a single color in the makeup of another color. See page 100.

**lazy Z:** The route your eye should take as it follows the action on your panels. See page 58.

**limited color:** A coloring technique whereby only one or two colors are used in addition to black and white. See page 42.

**limited color off-registration:** Applying color slightly off-register so the color doesn't line up perfectly with the black line art. Used to give the feeling of a silkscreen print. See page 44.

**limited line:** A drawing style used by some graphic novel artists. See page 14.

**liquid frisket:** A substance used in drawing to mask areas of the page that you don't want to ink. See page 88.

**manga special:** One of several nose shapes used by graphic novel artists. A highly stylized nose, popular with Anime and Manga artists. See page 26.

**medium shot:** Shows characters usually from about mid-thigh up. A good way to establish where your characters are in relation to each other. See page 47.

**model sheet:** A drawing of each character along with a full body shot and various poses and close-ups of the face carrying different expressions. Used for consistency as you are working through your story.

**motion blur:** A special effect used to create the impression that something is moving at a superhuman speed. See page 65.

**motion lines:** Lines used as a special effect to show that something is in motion. They can be straight, to suggest speed, or on either side of an object to show that it is shaking. See page 6.

**nose bubble:** An effect used to indicate that a character is in a deep sleep. See page 69.

**over the shoulder:** The view given to your reader when you want to demonstrate a conversation without using a side-to-side shot. Gives the

reader the sense of overhearing something said in private, without being part of the action. See page 47.

**owl:** A character who enjoys absorbing information, is detail-oriented, and prefers to work behind the scenes rather than as the center of attention.

**panels:** The boxes that hold the pictures on your page. Your story is made up of a series of these. See page 52.

**panel breakouts:** A drawing technique used to create a sense of action. The character literally breaks out of the panel. See page 41.

**panther:** An intimidating character, often a leader and very results-driven. Often impatient and direct, they don't mince their words.

**peacock:** Someone who is a socialite and likes being the center of attention.

**point of view:** A shot shown from one character's point of view. Useful when you want to show something shocking or make a specific point. See page 47.

**realism:** A style of drawing used by some graphic novel artists. See page 14.

**saturation:** How much color or ink you use on your page. See page 100.

**speedlines:** A Manga drawing technique used to add dramatic effect and filler to panels. See page 40.

**staging:** How you choose to arrange your characters within each panel. See page 54.

**starburst:** An effect used to represent a throbbing vein in someone's forehead. See page 68.

**steam machine:** An effect that uses steam to show a character has virtually exploded with rage. Usually shown blowing out of a character's ears or out of the top of their head.

**super sweat:** A technique used to suggest that a character is undergoing extreme tension and stress. See page 69.

**temperature:** Colors can be warm and cool. Using temperature theory helps you to set the mood. See page 99.

**thumbnails:** Smaller versions of your pages, useful for preliminary sketches of the novel's events in sequence and useful for organizing content and action, without going into the detail of the finished pages at full size. See page 60.

**three-quarter view:** A view of a character's head from a slightly turned angle. See page 144.

**tone:** The enhancing effect of adding gray to black and white artwork. Used to emphasize form, mood, and shadow.

**upside down 7:** One of several nose shapes used in the graphic novel genre, it

looks just like an upside down number seven. See page 26.

**value:** The lightness or darkness of a given color. See page 97.

**wacom:** A digital tablet used by graphic novel artists for drawing on. See page 182.

**water works:** Making a character look like they are crying so hard that they have turned into a virtual waterworks. Sometimes combined with a runny nose for emphasis. See page 70.

**worm's eye view:** A point of view used in graphic novels where the action is shown as if through a camera placed on the ground, from an extremely low angle which a worm might be watching from. Effective in showing the size of your characters or making someone look intimidating. See page 47.

# Comic book stores

There are loads of great comic book stores around, and there wouldn't be graphic novels without them! Here is a very partial list of some notable ones:

## USA
That's Entertainment
244 Park Ave Worcester MA
www.thatse.com (508) 755-4207

Wonderland Comics
112 Main Street, Putnam CT
www.wonderlandcomics.com (860) 963-1027

Jim Hanley's Universe
33rd Street New York NY
www.jhuniverse.com

Mid Town Comics
200 W 40th Street, NY
www.midtowncomics.com  (212) 302-8192

Casablanca
151 Middle Street, Portland ME
www.casablancacomics.com

Cup O' Kryptonite
4521 Fleur Drive, Des Moines IA
www.cupokryptonite.com (515) 974-0515

Captain Blue Hen Comics
280 E. Main Street Newark DE

www.captainbluehen.com
(302)737-3434

Harrison Comics
252 Essex Street, Salem MA
www.harrisonscomicsltd.com (978) 741-0786

Friendly Neighborhood Comics
191 Mechanic St. Bellingham, MA 02019
www.friendlycomics.com (508) 966-2275

Chicago Comics
3244 North Clark St, Chicago IL
www.chicagocomics.com (773) 528-1983

Golden Apple Comics
7018 Melrose Ave, Los Angeles CA 90038
www.goldenapplecomics.com (323) 658-6047

Million Year Picnic
99 Mt Auburn St, Cambridge MA
www.themillionyearpicnic.com (617) 492-6763

Graham Crackers Comics
9 Locations in Illinois
www.grahamcrackers.com (312)
629–1810

**UK**

Forbidden Planet
Multiple locations throughout the UK
www.forbiddenplanet.co.uk

The Comic Guru
11 Plasmelin
Westbourne Road
Whitchurch
Cardiff CF14 2BT
www.thecomicguru.co.uk
(02920) 251–487

# Credits

# Index